IMAGES
of America

CHIMAYÓ

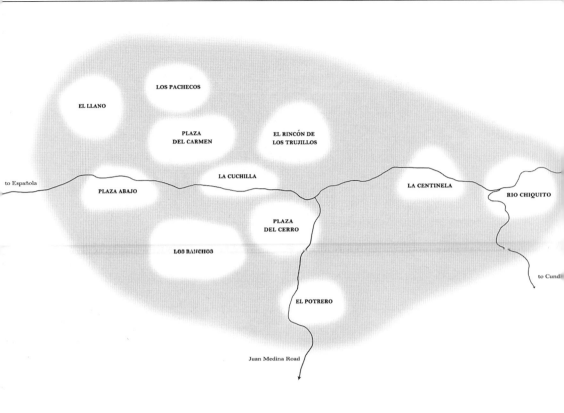

Placitas of the Chimayo Area

LOS PACHECOS

EL LLANO

PLAZA
DEL CARMEN

EL RINCÓN DE
LOS TRUJILLOS

LA CUCHILLA

to Española

PLAZA ABAJO

LA CENTINELA

RIO CHIQUITO

PLAZA
DEL CERRO

LOS RANCHOS

to Cundi

EL POTRERO

Juan Medina Road

N

0 1
mile

Chimayó is an area that is made up of *placitas* (little neighborhoods) that began as scattered ranchos (farms or ranches) and gradually grew into clusters of homes belonging to extended families. This map gives the reader an idea of the location of these placitas in relationship to each other. (Courtesy of Susan Hayre.)

On the Cover: This 1910 image shows a procession of men and women walking to El Santuario de Chimayó. (Courtesy of Palace of the Governors Photo Archives Library of the Museum of New Mexico, Negative 014379.)

IMAGES
of America

CHIMAYÓ

Patricia Trujillo-Oviedo

ARCADIA
PUBLISHING

Copyright © 2012 by Patricia Trujillo-Oviedo
ISBN 978-0-7385-8543-7

Published by Arcadia Publishing
Charleston, South Carolina

Printed in the United States of America

Library of Congress Control Number: 2011939111

For all general information, please contact Arcadia Publishing:
Telephone 843-853-2070
Fax 843-853-0044
E-mail sales@arcadiapublishing.com
For customer service and orders:
Toll-Free 1-888-313-2665

Visit us on the Internet at www.arcadiapublishing.com

*I dedicate this book to my tenacious, hardworking, courageous,
perseverant, and devout ancestors who settled Chimayó.*

CONTENTS

Foreword 6

Acknowledgments 7

Introduction 8

1. Stewards of the Land 9

2. Faith and Devotion 25

3. Following Traditions 43

4. Weaving and Weavers 63

5. Chimayó Chile 81

6. Families and Elders 89

7. Into the Next Century 105

Bibliography 127

FOREWORD

For those of us with roots in Chimayó, these historic photographs assembled by Patricia Trujillo-Oviedo are mirrors that show us who we are. We see ourselves reflected in the grainy black-and-white images, in the gaze of ancestors and distant relatives peering at us across a gulf of time. The pictures transport us inward on a journey of self-discovery that anchors us firmly in place and profoundly connects us to this old, deeply rooted community. At the same time, the pictures fuel a vivid imagining of what life was like "in the old days," times that we have heard of from our elders as they recount stories of long ago and not so far away. Patricia has arranged these images so that they fill out the vision conveyed by oral tradition, showing us how people survived, worshipped, celebrated, and endured difficult times to bring us here. We look back in wonder at all that these *antepasados* accomplished and wonder if we can match them in bequeathing to future generations such a legacy of faith and persistence.

I have spent much time searching out stories and bits of information about the history of this remarkable community, Chimayó, spending many hours in many homes, asking questions, and listening to stories. In the process, I have glimpsed countless old photographs hanging on the walls in the *salas* (living rooms), propped up on tables, or glued onto the yellowed pages in old albums. People cherish these old pictures and keep them carefully, the same way that they remember long lists of ancestors' names and stories about them. The well-kept photograph collections reflect the deep appreciation that Chimayósos feel for their ancestors, their love of family, and their pride in their history—a history that has been devalued for many years and given short shrift in the narratives of American identity that are recited in public schools, museums, and other institutions. Never mind that they were taught to memorize stories from the history of the New England colonies while learning little about the stories of Spanish colonial life at this far-flung frontier—the people in Chimayó have kept their photographs close to their hearts. And now Patricia has put many of them together, bringing them from the salas and scrapbooks—and some from historical collections in Santa Fe—to tell, through pictures, the story of this small community with such a large and rich history.

The number of people connected to this history has grown greatly in the 300-plus years that Chimayó has been settled. These photographs make us not only think deeply about the value of our history, but *feel* it deeply—an emotional reaction that will strike even those without family in northern New Mexico. They commemorate a slice of Americana that all can appreciate and learn from.

—Don J. Usner, author and historian

ACKNOWLEDGMENTS

I would like to thank the many generous people who shared photographs and family histories with me. Many thanks go to Mickie Medina, Josie Martinez, and Rosina Martinez for their help and encouragement, and my brother Irvin Trujillo and his wife, Lisa, for sharing their broad knowledge of Chimayó weaving and weavers and for providing me with many of the photographs from the Jake O. Trujillo family collection and the Mercedes Trujillo collection. In addition, I would like to thank Robert and Andrew Ortega, Carlos Trujillo and Carol Alarid, and Tim Cordova for sharing their families' collections of photographs of and historical information about weavers. I thank Elma and Raymond Bal, Vickie Bal-Tejada, Dennis and Leona Tiede, David and Diane Martinez, Angelica Martinez Medina, Marcela Martinez Garduño, Joe N. Trujillo, Lindsey Trujillo, and Dulcinea Vigil for sharing many of their family photographs and historical information. A thank-you goes to María Móntez-Skolnik for allowing me to use photographs from the Emma Jaramillo Montes collection, to Danny Jaramillo for his time and knowledge of Chimayó history, and to the Chimayó Cultural Preservation Association and the Palace of the Governors Photo Archives Library of the Museum of New Mexico for permission to use their historical photographs. My appreciation goes to John Abrams, Wrey Ortiz, and Suellen Strale, who provided photographs or historical information.

Special recognition goes to Arturo Jaramillo and Florence Poulin Jaramillo, who have preserved the Spanish culture and heritage and shared it in the Rancho de Chimayó Restaurante, and to Don Usner for documenting Chimayó history that helped sharpen the focus of this book. Special thanks also go to Susan Hayre for her technical assistance and encouragement, to Fr. Julio Gonzalez, S.F., for his insight and knowledge, and to Victor Archuleta and Dennis Tiede for the genealogical information they provided on families of Chimayó. I thank all my family and friends who have encouraged me with this endeavor—especially my husband, Marco, for his special support and encouragement in this project, and my son Jacobo Javier for his help and his invaluable advice and knowledge.

INTRODUCTION

Chimayó lies in the foothills of the Sangre de Cristo Mountains, between Santa Fe and Taos, and was settled by Spanish colonists after the Pueblo Revolt of 1680 and peaceful reconquest in 1692. Chimayó got its name from a high mountain to the east of the valley that was called Tsi Mayoh by the nearby Tewa Indians, who believed that the area was sacred and had healing earth.

New settlers coming through Mexico following the Camino Real were no longer looking, as earlier conquistadores were, for riches in the New World, but for a place to start a new life in areas where land would be granted to them. The first settlement, established by Don Diego de Vargas after the reconquest, was at Santa Cruz de la Cañada. Later, some families moved east to Chimayó to found what became known as La Plaza de San Buenaventura de Chimayó. Two of the original families in Chimayó—the Ortegas and Trujillos—were weavers.

Chimayó became an area of small communities, often named for families that initially settled the land, like El Rincón de Los Trujillos and Los Pachecos. Other names followed the description of local geographic features: Plaza del Cerro (nearer the hill), Plaza Abajo (at lower end of the valley) El Potrero (near horse pastures), La Cuchilla (knifelike ridge), Los Ranchos (large farm fields), La Centinela (outpost for sentinels), Rio Chiquito (little river), and El Llano (flat plain).

People's daily lives were influenced by faith. Poems or songs composed while working were usually also a prayer to a patron saint. Both men and women belonged to organizations. In 1695, De Vargas started a religious and protective society for women, known as Las Carmelitas, in Santa Cruz. The Carmelitas prayed at Mass or at wakes. Dating back to the time of Oñate in 1598 was a brotherhood of men known as the Penitentes that was a Third Order of St. Francis. The Penitentes provided a spirit of penitence and community generosity as they led prayers at funerals and Lenten observances. Their moradas (chapter houses) were adorned with icons of saints who exhibited the same suffering as Christ and represented examples the brothers followed.

In 1810, Bernardo Abeyta, a Penitente brother carrying out his traditional Holy Week penance, discovered a crucifix of Our Lord of Esquipulas. Soon after, Abeyta reported his find and requested permission from priests in Santa Cruz to build a chapel at the site of his discovery. When Fr. Sebastian Alvarez of Santa Cruz wrote to the Bishop of Durango in 1813 asking permission to build a church where the crucifix was found, he noted the curative powers of the earth to which many attested. Permission was granted, and Santuario de Chimayó chapel was completed in 1816.

The Santuario de Chimayó remained privately owned until the early 1930s, when it was purchased by a group of people who formed the Spanish Colonial Arts Society. The chapel was then donated to the Archdiocese of Santa Fe and has been under the care of the Holy Family Parish in Chimayó since the parish was created in 1959. Fr. Casimiro Roca, appointed pastor at that time, restored the chapel structure. It was registered as a national historic landmark in 1970.

In the 19th century, New Mexico was exposed to trade (the Santa Fe Trail), other governmental rule (first Mexico, then the United States), and the introduction of the railroad in 1880. The period between 1870 and 1920 is characterized as a transition from relative self-sufficiency of 19th-century Hispanic village life to marked dependence on the more complex economy of the United States. Even with these major changes, people maintained age-old traditions in their family life.

Today, the people of Chimayó continue to follow basic traditions brought here by the Spaniards four centuries ago. Their lifestyles may have evolved, especially after World War II—since most of the people have had to work elsewhere, often in surrounding cities—but the apple orchards and chile fields are still maintained and endow Chimayó with a reputation for hot chiles and delicious apples. Weaving of Chimayó blankets is still the most notable pastime. The Santuario de Chimayó has become a world-renowned shrine visited by thousands of pilgrims each year. The roads to Chimayó have been traveled by pilgrims since ancient times and continue to draw visitors. The heritage, folklore, and tradition of the area are still important influences on the lives of the present-day people of Chimayó.

One

STEWARDS OF THE LAND

Archeological records show that Native Americans occupied the region known as Chimayó from 1000 to 1100 AD. The semidesert environment, with somewhat extreme temperature and moisture conditions, makes Chimayó a rather harsh place to survive off of the land. However, at times, prehistoric people were able to rely on rainfall alone to water their crops. Precipitation increased eastward from the Rio Grande to the Sangre de Cristo Mountains, giving rise to a series of vegetation types from grassland to woodlands of piñon and juniper trees in the foothills. Vegetation dependent on flowing water follows streams that course through rugged terrain.

The original pioneer families who came to Chimayó and colonized the area had to be self-sufficient, but also had to rely on formation of communities for mutual help and defense against disgruntled natives. They quickly learned from the natives that the best method of housing construction was from mud—a mixture of a certain type of soil that held together to withstand the eroding actions of wind, rain, and snow. Back in Spain, they had learned from the Moors to make mud bricks, called adobe, and thus they improved their buildings. Every piece of land accessible to water fostered permanent homesites. Water from natural streams was channeled into a network of irrigation systems called acequias, and scattered ranchos gradually grew into clusters of homes belonging to extended families.

Colonists brought with them livestock that was unknown to the area—horses, donkeys, cattle, sheep, pigs, and chickens. They also brought knowledge about planting and harvesting wheat and learned from their native neighbors that corn, squash, and beans could also be planted to provide nourishment throughout the year. Beans were harvested dry and would keep through the winter. The colonists had brought seeds of fruit, like apples, peaches, pears, cherries, apricots, and plums, that they could plant in order to grow trees that produced fruit. The dry, warm days of fall provided the perfect environment to dry the fruit to store it for winter consumption.

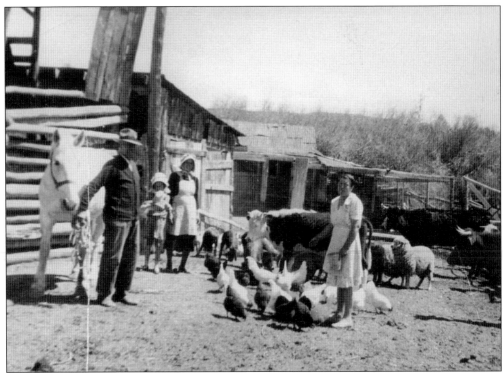

In this 1940 photograph, Isidoro Trujillo of La Centinela stands with his wife, Francisquita, granddaughter Margaret, and daughter Mercedes (right), surrounded by the livestock they raise to provide nourishment in the form of food and to help them plow the fields. (Courtesy of Mercedes Trujillo collection.)

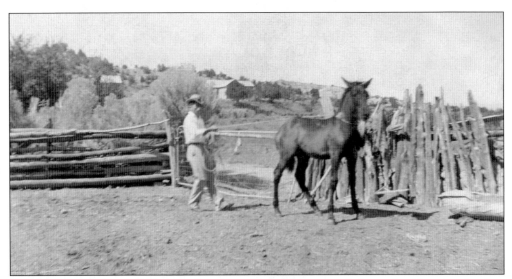

In order to protect livestock from predators, rancho owners surrounded corrals with coyote fencing, which was made with straight branches of trees tied together to prevent predators from coming into the corral. In this 1935 photograph, Jake O. Trujillo ropes a horse in a corral representative of this type of construction. (Courtesy of Jake O. Trujillo family collection.)

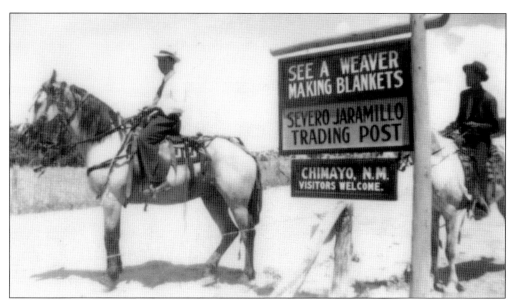

Men from Chimayó would travel to southern Colorado and as far as Wyoming to bring back horses to sell to their neighbors. These horses were half-draft and could be used for pulling a wagon or plow or for riding. The 1940 photograph above shows Jake O. Trujillo posing for a postcard photograph; note the size of the horse and the use of both harness and saddle tack. The 1950 photograph at right shows this type of horse pulling a plow held by Esteban Trujillo, assisted by his sons Reyes and Esquipulas (in front). (Above, courtesy of Jake O. Trujillo family collection; right, courtesy of Dulcinea Vigil.)

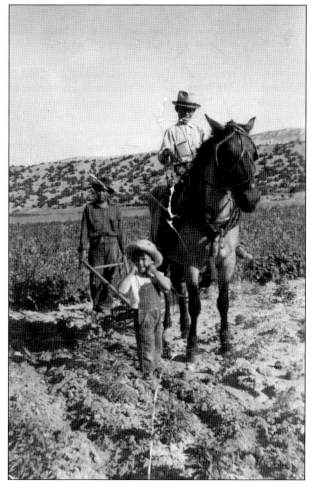

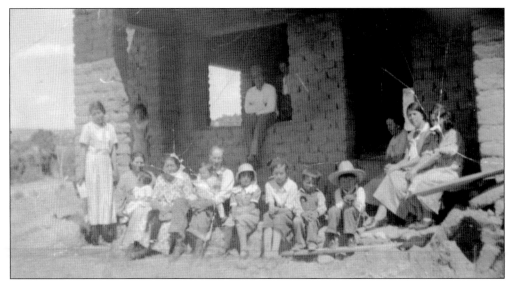

The 1935 photograph shows the whole family participating in the construction of an adobe house at La Centinela. Adobe brick and the architectural style its use spawned in Spain were brought to New Mexico with the early Spanish settlers. A mixture of mud, sand, and straw is molded into bricks and then baked in the sun. An adobe house provides good insulation in both heat and cold. (Courtesy of Jake O. Trujillo family collection.)

Wooden doors, as seen in this 1954 image of an adobe garage in La Cuchilla, were made from hand-hewn logs dragged from the nearby mountains by mules, donkeys, or oxen. The logs were then raw cut into boards. Nails could be bought or traded for at Bond and Nohl mercantile store in Española, which was established after the 1879 arrival of the railroad. (Courtesy of Horacio and Rosina Martinez.)

Before people in Chimayó could afford to buy tractors, plowing was done with the help of horses, donkeys, mules, or oxen. The 1964 photograph at right shows Enemecio Martinez plowing in the Plaza Abajo with the help of a donkey. His son Anthony helps him handle the donkey, and his granddaughter Lucia walks with them. After World War II, when there were job resources in Santa Fe or Los Alamos, tractors became more common because people had the means to buy them. Below is a 1957 photograph of Jake O. Trujillo using one of the first tractors in Chimayó to plow a small field at La Centinela. (Right, courtesy of Mickie Medina; below, courtesy of Jake O. Trujillo family collection.)

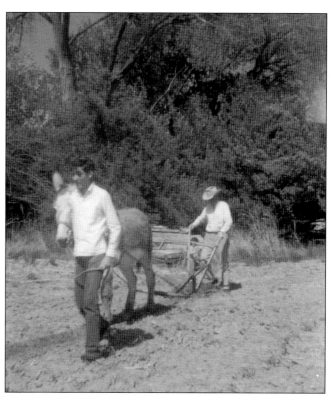

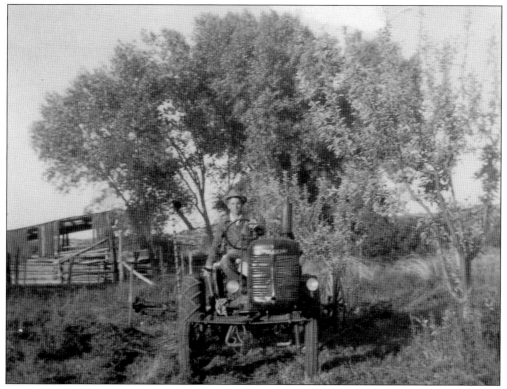

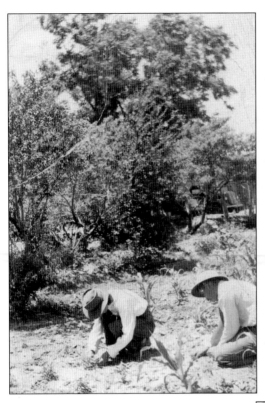

Since families grew the majority of their food, much care was taken in planting the garden. When sowing chile, several seeds are planted together so that there is more chance for plants to germinate. Once germinated, often the plant must be thinned in order to grow a stronger plant. This 1950 photograph shows the Medina family thinning chile plants. (Courtesy of Dennis and Leona Tiede.)

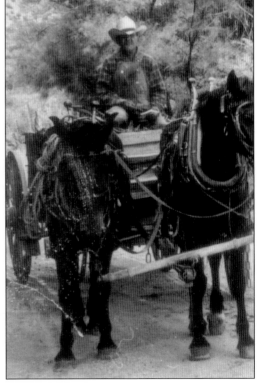

The wagon was not only a method of personal transportation, but also a vehicle for carrying produce to market, carrying cut hay from field to storage, and bringing supplies from nearby towns like Santa Fe and Española. This 1950 photograph of Jose Inez Vigil shows him driving his horse-and-wagon team when there were still few cars or trucks in the area. (Courtesy of Jake O. Trujillo family collection.)

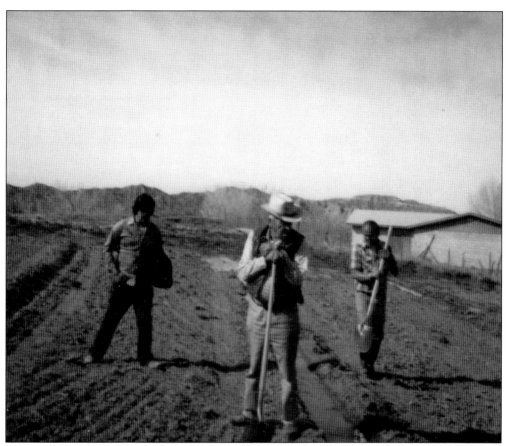

The area's original settlers built an extensive network of acequias (irrigation ditches) to provide water for crops and adapt this semi-desert region to irrigation agriculture. The origin of acequias can be traced back to Moorish, Spanish, and Indian sources. Before the Spanish came, Native Americans were practicing crude irrigation techniques; the settlers brought new knowledge about the practice and technology. The 1960 photograph above shows Equipula B. Martinez and sons irrigating a newly planted chile field in La Cuchilla. The 1964 photograph below shows Enemecio Martinez irrigating his cornfield in the Plaza Abajo (Above, courtesy of Horacio and Rosina Martinez; below, courtesy of Mickie Medina.)

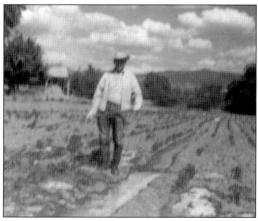

The acequia system was made up of several *compuertas* (irrigation gates) that opened up into different lots. This 1970 photograph shows Irvin Trujillo changing water at the compuerta on the La Cañada Ancha ditch at La Centinela. (Courtesy of Irvin Trujillo.)

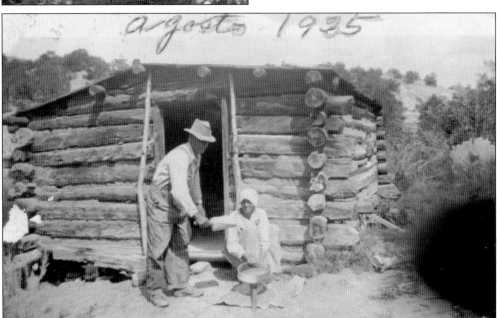

The Spanish settlers brought wheat with them and planted it in addition to the beans, corn, and squash they got from their native neighbors. They built mills near an irrigation ditch (acequia) to grind the wheat into flour. This 1935 image shows Isidoro Trujillo with his wife, Francisquita, in front of a log-built *molino* (mill) where they ground wheat for flour. (Courtesy of the Jake O. Trujillo family collection.)

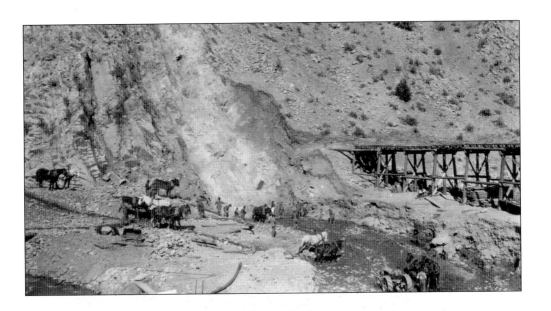

The Santa Cruz Dam was built to conserve water coming from two mountain streams, the Rio del Medio and the Rio Frijoles, into the Santa Cruz River and to provide irrigation to those below the dam. The reservoir, called Santa Cruz Lake, served as a recreational area for boating and fishing. Above, a 1929 photograph shows how the dam was built using teams of horses and mules and one or two tractors to move dirt. In the 1929 photograph below, various dignitaries gather at the top of the dam as Fr. Salvador Gene blesses the nearly completed structure. (Both, courtesy of the Jake O. Trujillo family collection.)

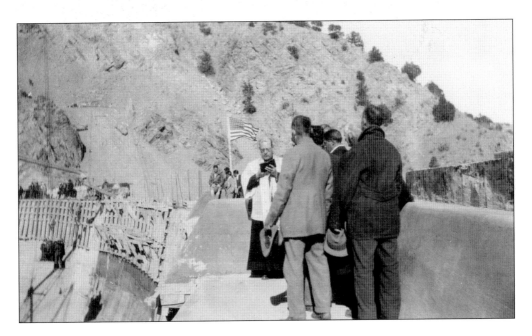

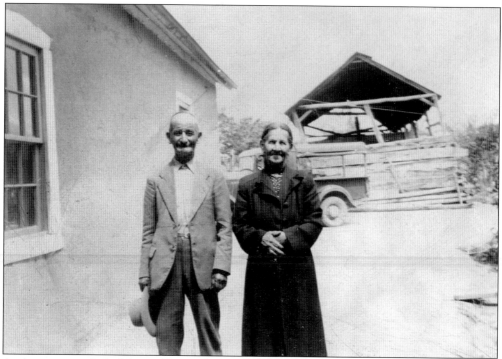

As the economy shifted from self-sustaining to cash-based, people in Chimayó not only produced crops for their own sustenance but also to sell. One of the first people to own a pickup truck was Jacinto Ortiz. Ortiz and his wife, Benita, planted corn, chile, melons, and other produce to sell in nearby Española. In the 1940 photograph above, Jacinto and Benita prepare to take produce to market. Many others transported produce by wagon, as shown in the 1940 photograph below of Isidoro Trujillo, with his son Rosinaldo and granddaughter Elenita Jaramillo. (Above, courtesy of Angelica Medina; below, courtesy of the Mercedes Trujillo collection.)

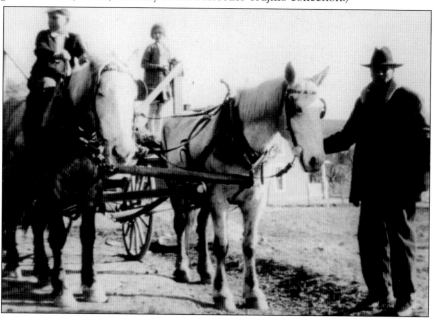

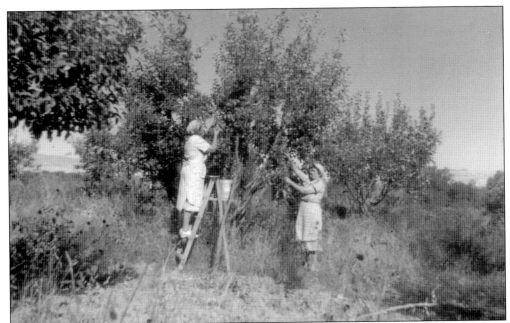

People in Chimayó were industrious and found ways to make money from selling the food they grew or produced. Although the early settlers planted scattered apple trees, families established large apple orchards after World War II, obtaining young seedlings from nurseries in other parts of the country. The 1959 photograph above shows Teresita Jaramillo and her sister Mercedes Trujillo picking apples to sell. Other entrepreneurs included Dan and Mickie Medina, who raised over 1,500 laying hens. The 1958 photograph at right shows Mickie Medina and her brother Anthony Martinez gathering eggs to sell in nearby Española and Los Alamos. (Both, courtesy of Mickie Medina.)

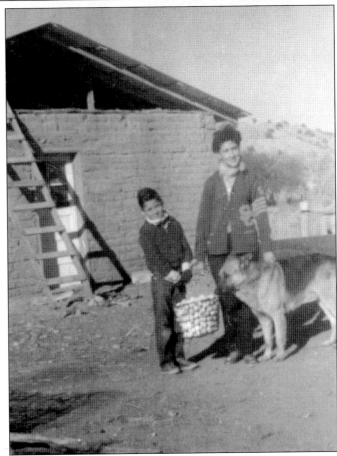

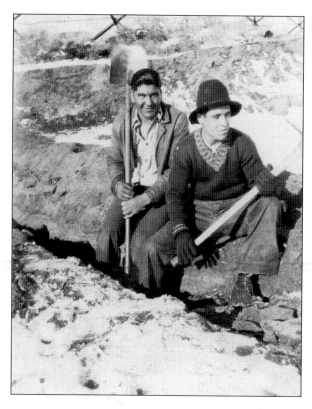

The ditch boss (*mayordomo de la acequia*) was an important person in the community because he directed the use of irrigation water. Beginning in early spring, the mayordomo organized the ditch cleaning. In the 1926 photograph at left, Vidal Martinez and an unidentified companion clean La Acequia de los Martinez. Throughout the summer, the mayordomo was in charge of parceling ditch water usage out to users of the acequia according to the water rights owned. In the 1970 photograph below, Vidal Martinez, mayordomo of the Martinez ditch, is pictured with the acequia that he oversaw during the 1970s. (Both, courtesy of David and Diane Martinez.)

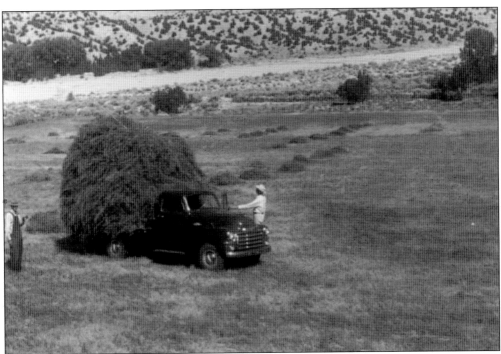

Grass and alfalfa hay was cut, gathered, loaded onto wagons, and transferred to hay lofts or special barns called *zacateras* for winter feeding of livestock. Alfalfa hay was introduced by the Spaniards and grown in irrigated fields, and grass hay mostly came from pastures that were naturally sub-irrigated. In the 1950 photograph above, Encarnación Trujillo (left) and his son John stand next to a truck loaded with alfalfa from an irrigated field. Below is a photograph of a typical zacatera, built with stacked and intertwined logs and roofed with corrugated metal. This type of construction was popular after the availability of metal roofing material was increased with the railroad. (Above, courtesy of Carlos Trujillo; below, courtesy of Horacio and Rosina Martinez.)

The Pueblo Indians introduced corn, a staple food item, to the Spanish. Long rows of corn could be planted in irrigated fields. In the 1967 photograph at left, Enemecio Martinez is in a *milpa* (field of corn) he is cultivating. Harvesting corn included shucking or peeling the husks from the ears of corn. The corn was then dried and leached in lime for posole (like hominy), dried and roasted in an *horno* for *chicos*, or dried and ground for cornmeal to make *chaquehüe* (gruel-like cereal), atole (cornmeal drink), or tortillas. In the 1978 photograph below, Dimas Vigil, from Rio Chiquito, shows his granddaughter Jessica Pacheco how to shuck corn. (Left, courtesy of Mickie Medina; below, courtesy of Dulcinea Vigil.)

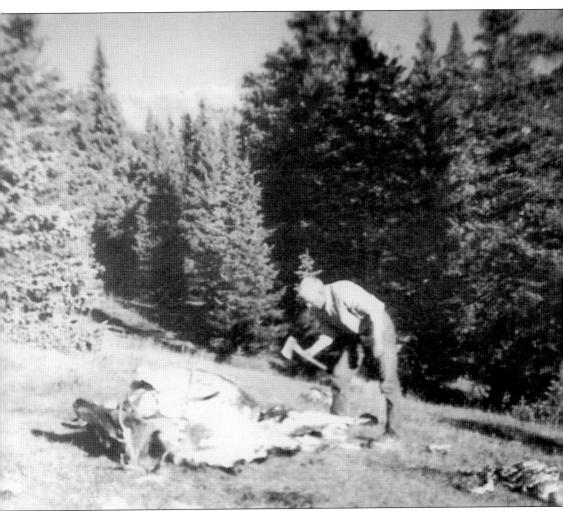

Meat obtained from domestic animals such as cows, pigs, and sheep was added to a diet that consisted mostly of beans, corn, wheat, and fruit. After an animal was slaughtered, the meat was jerked, salted, and dried for later use. Sausage could also be made from miscellaneous parts of the animals. Cow intestines were cleaned, dried, and used for sausage casings. Some meat was also obtained from wild animals, such as deer and elk, which were hunted in the nearby mountains. This 1985 photograph shows Esquipula Vigil skinning and quartering an elk that he hunted in the mountains east of Chimayó. The quartered carcass was then packed on a mule or horse and brought home to jerk and dry for later use. (Courtesy of Dulcinea Vigil.)

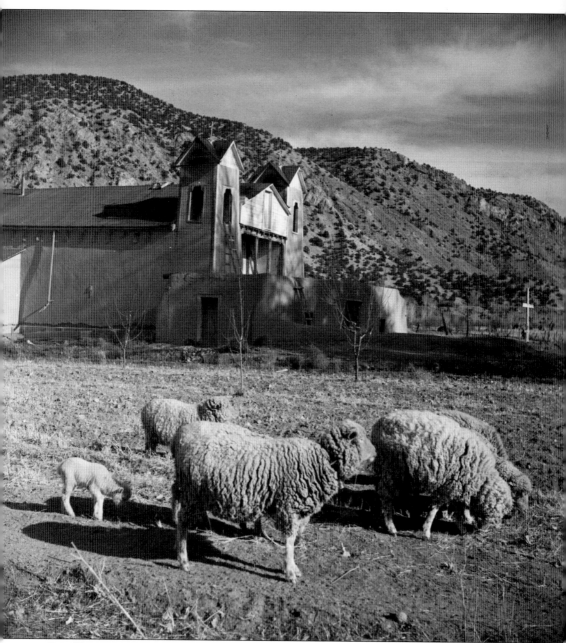

In addition to meat, sheep also provided wool that could be made into cloth or blankets. The Chimayósos not only worked to provide food and clothes for themselves, but also maintained a strong religious and spiritual well-being. Many feast days of patron saints matched the yearly agricultural cycle. For example, the week before Holy Week was the time to clean acequias. Planting was done by May 15, feast day of San Isidro—the patron of farmers. The corn harvest started on June 24, feast day of San Juan; the blessing of fields was done on the feast day of Santiago, July 25; harvesting green chile began on August 11, feast day of Santa Clara. This 1940 photograph depicts the Santuario de Chimayó with sheep grazing in the foreground. (Courtesy of Palace of the Governors Photo Archives Library of the Museum of New Mexico, Negative 100373.)

Two

FAITH AND DEVOTION

The people who settled in Chimayó brought with them a strong Catholic religion. Their daily life was guided by faith, as exemplified by the feast days of saints that coincided with the planting and harvesting cycle.

Many men of the community were members of the lay Franciscan brotherhood known as the Penitentes. Women belonged to a lay society known as the Carmelitas, who had devotion to Our Lady of Mount Carmel, and would gather together to pray and go on processions to honor the feast days. The Penitentes provided the spirit of penitence and generosity to the community as they led prayers at funerals, feast day celebrations, and Holy Week observances, especially in the time when there was a shortage of priests. They met to pray in secrecy—especially during Lent—in their moradas (chapter houses), and often reenacted the Passion of Christ as they processed to a *calvario* (a hill with a cross that symbolized Calvary). The altars inside the moradas were adorned with icons of saints who exhibited the suffering of Christ and whose lives were examples the brothers followed as they lived their lives.

A chapel, usually dedicated to the favorite patron of a prominent family, was built in every plaza or neighborhood. The chapel could also be constructed in thanksgiving for a favor. The best-known chapel in the area, the Santuario de Chimayó, was built by Bernardo Abeyta, a Penitente, at the site where he found a crucifix of Our Lord of Esquipulas (named after Esquipulas, Guatemala) in 1810. The area where the crucifix was found was known for its healing earth since before Spanish settlement.

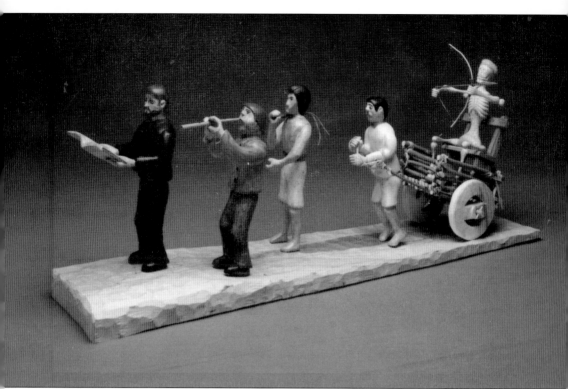

The shortage of priests made it difficult to serve outlying places like Chimayó. Many men in the communities were members of the Brotherhood of Penitentes, who kept the Catholic religion alive. They had a penitential manner of devotion, and during Holy Week, members of the Penitente Brotherhood would gather at their chapter house (morada) and process to El Calvario to reenact the passion. The procession for penance, as demonstrated by the figurines in the picture, was led by *El Hermano Mayor* (head brother), also called *El Rezador* (the prayer leader). He was followed by *El Pitador* (the flute player), *El Flagelador* (the one flagellating himself) and *La Carreta de La Muerte* (a cart carrying an allegorical figure of death known as Doña Sebastiana). The Penitentes were very aware of their mortality and reminded themselves of this through symbolic images. (Photograph of a woodcarving by Marco A. Oviedo depicting the Procession of Penitentes, courtesy of Robert Vogele.)

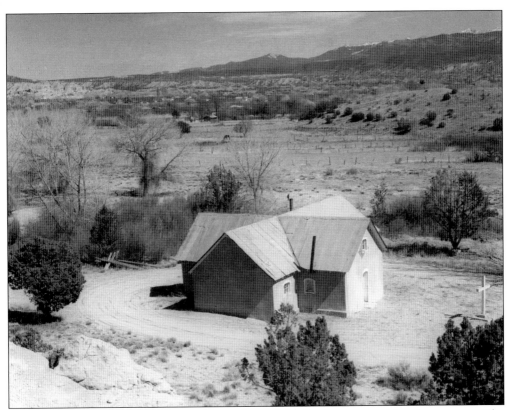

A morada was a chapter house where members of the Penitentes would gather to pray. The above photograph shows La Morada de Santa Rita, in the Plaza de Abajo of Chimayó, which is built in the shape of a cross. Crosses used for penitential processions are visible to the left of the structure. The altar in the morada is shown below. The banner at left identifies the Santa Rita Chapter of the Brotherhood of Our Merciful Father Jesus the Nazarene. On the altar are dressed bultos (carved images) of Santa Rita, *Nuestro Padre Jesus* (Our Father Jesus), and three of *Cristo Crucificado* (symbolizing the Holy Trinity). (Both, courtesy of Josie Martinez.)

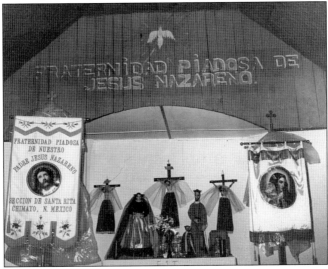

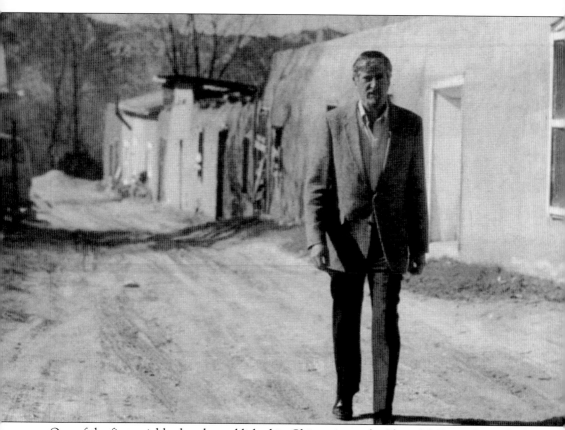

One of the first neighborhoods established in Chimayó was the Plaza del Cerro. It was built as a defensive plaza, with houses lined up next to each other in the form of a square with only two openings. On the west side, a community chapel called the Oratorio de San Buenaventura (Prayer Shrine of St. Bonaventure), was built and served as a religious center for the community through the 1800s and well into the 20th century. In 1954, the Spanish Colonial Arts Society contributed funds to buy materials for its restoration. Under the direction of Hermenejildo Jaramillo, labor was supplied by the Carmelitas, who mud-plastered the chapel, and the restoration was completed in 1954. The chapel was turned over to the Archdiocese of Santa Fe soon after. Arturo Jaramillo, grandson of Hermenejildo, walks by the Oratorio, located on the west side of the plaza. This photograph appears in the *Empire Magazine* article "Chimayó, Land of Many Weavers," in the May 5, 1985, *Denver Post*. (Courtesy of the Jake O. Trujillo family collection.)

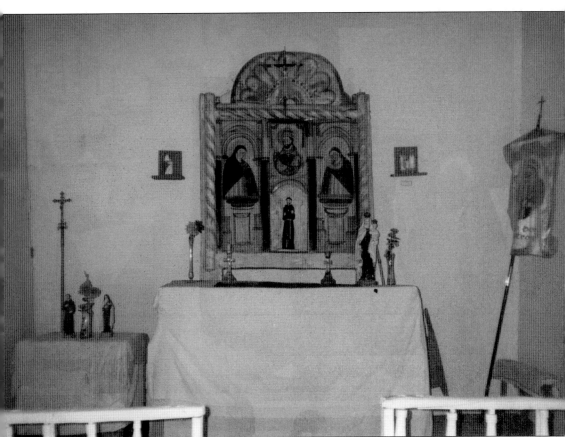

The altar at the Oratorio de San Buenaventura at Plaza del Cerro, pictured here in 1988, contains an original altar screen made by Rafael Aragon between 1820 and 1850. The banner of *Nuestra Señora del Carmen* (Our Lady of Mount Carmel), on the right, was used to lead processions by a laywomen's prayer group known as Las Carmelitas, who processed to or from this oratorio while saying the rosary and singing hymns. Bultos (carved images of saints) on the altar include *San Buenaventura* and *Nuestra Señora del Carmen*. The side altar has bultos of *San Francisco* and *Santa Teresa de Jesús*, with a votive candle and flower in between. Two small retablos (painted boards) with unidentified images are on each side of the main altar. (Courtesy of Holy Family Parish Archives.)

A privately owned chapel in honor of Santa Rita, the patron saint of the impossible, was built in 1929 by Enemecio Martinez, Apolonio Martinez, and Pedro Fresquez on a hill in the Plaza Abajo. Sometime around 1936, Fresquez discovered a spring of water in a cliff behind the chapel. The water from the spring has been used for healing purposes, and the Martinez family regularly visits the chapel. The 1929 photograph at left was taken when the chapel was built, and the photograph below shows the chapel after it was plastered with stucco in 1960. (Both, courtesy of Josie Martinez.)

Privately owned chapels were adorned with santos (both carved images, called bultos, and those painted on boards, called retablos) that represented favorite patron saints of the owners. This 1940 image shows the altar at the Santa Rita Chapel, with a ceramic statue of Santa Rita in the upper center surrounded by other, smaller religious icons. Several votive candles and flowers adorn the altar. (Courtesy of Josie Martinez.)

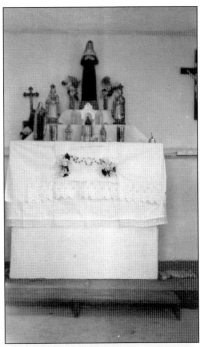

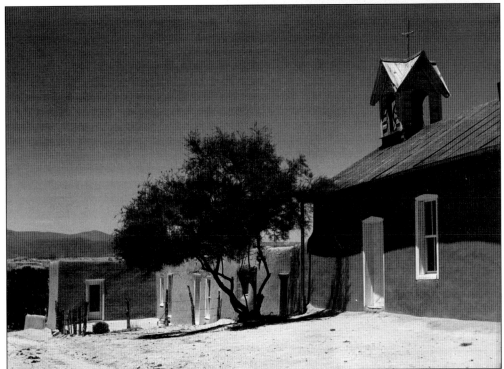

La Cuchilla Chapel, dedicated to Our Lady of Mount Carmel, was built in 1840 and maintained by the Espinosa and Martinez families. The chapel served the people living near La Cuchilla, Plaza del Carmen, as well in El Rincón de Los Trujillos. (Courtesy of Palace of the Governors Photo Archives of the Museum of New Mexico, Negative 166619.)

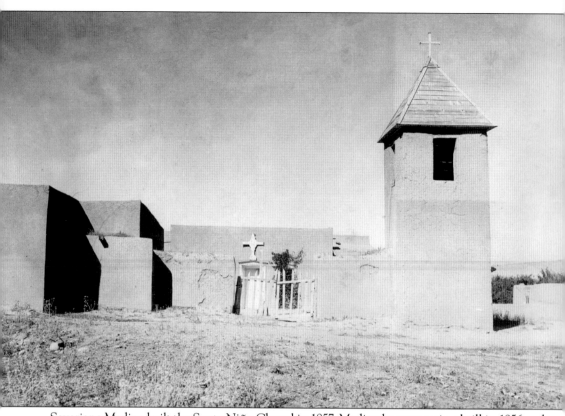

Severiano Medina built the Santo Niño Chapel in 1857. Medina became seriously ill in 1856 and prayed to *El Santo Niño* (the Holy Child, aka Jesus Christ) for healing. Upon his recovery, he made a special pilgrimage to a shrine of El Santo Niño in Fresnillo, Mexico. When he returned, he obtained permission to build a private chapel in honor of El Santo Niño de Atocha in Chimayó. The chapel is next door to El Santuario de Chimayó and is extensively visited, especially since Santo Niño is the patron saint of pilgrims and travelers. The Medina family sold the chapel to the Archdiocese of Santa Fe in 1992, and it is now under the care of Holy Family Church in Chimayó. This photograph shows the chapel around 1910. (Courtesy of Palace of the Governors Photo Archives of the Museum of New Mexico, Negative 014617.)

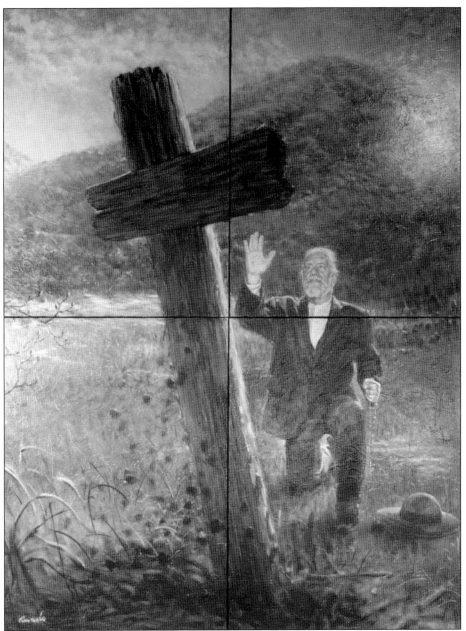

Bernardo Abeyta was a member of the Hermandad de Nuestro Padre Jesús Nazareno (Brotherhood of Our Father Jesus Nazarene) Penitente brothers from El Potrero who built the Santuario de Chimayó. In 1810, Abeyta is said to have been participating in Holy Week penance activities at a nearby hill when he saw a light near the Santa Cruz River below. He proceeded to follow the light and uncovered a crucifix of Our Lord of Esquipulas. He requested permission from the bishop of Durango, Mexico, through Fr. Sebastián Alvarez (the priest in Santa Cruz) to build a chapel at the site. Father Alvarez told the bishop about the healings that had taken place, and the chapel was completed by 1816. This photograph is of a painting by Ron Rundo of his interpretation of Abeyta discovering the crucifix. (Photograph by Richard Rieckenberg, courtesy of El Santuario de Chimayó.)

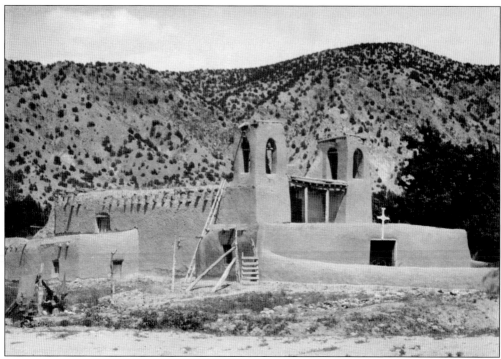

The Santuario de Chimayó was constructed of thick adobe walls with hand-hewn vigas (logs) supporting a mud roof. These photographs show the Santuario de Chimayó about 100 years after it was built. Deterioration of the mud plaster is visible, especially near the roof and tops of the bell towers. There appears to be more deterioration of the building walls in the 1904 photograph above than in the 1915 photograph below, and the fences had been removed by the time the later photograph was taken. (Both, courtesy of Palace of the Governors Photo Archives of the Museum of New Mexico, Negatives 022927 and 014368.)

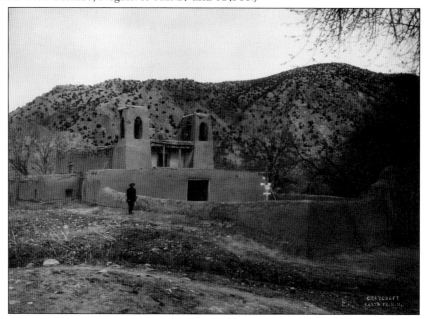

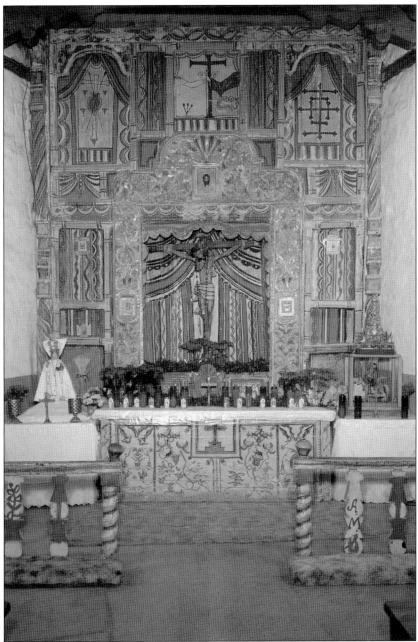

Bernardo Abeyta commissioned artists of his time to paint five reredos (series of sacred paintings)—one behind the main altar and two on each side of the nave. Behind the main altar at the Santuario is the largest reredos painted by Antonio Molleno, aka the "Chili Painter." The main image in the center is *Nuestro Señor de Esquipulas*, depicting the "black Christ" of Guatemala crucified on a cross in the form of the Mayan tree of life. From left to right, the reredos on the top row depict a cross with a lance and rod with a sponge and a heart with four wounds; the Franciscan emblem; and the Jerusalem cross. At lower left is a stalk of wheat that symbolizes the bread of life, and on the right, a bunch of grapes—the symbol of consecrated wine or the blood of Christ. A carved and painted tabernacle is attached to the reredos. (Courtesy of Sons of the Holy Family.)

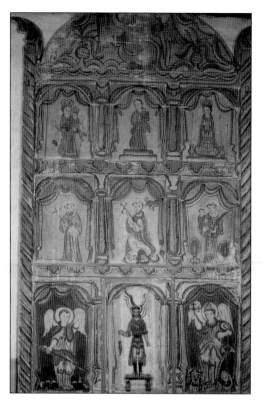

Jose Aragon of Chamisal painted the reredos on the left as one enters the chapel. The figures from left to right and top to bottom (left photo) include Our Lady of Mount Carmel, Mary the Immaculate Conception, and Our Lady of St. John of the Lakes; St. Francis of Assisi, St. Jerome, and St. Anthony of Padua; and St. Gabriel Archangel, St. Rafael Archangel carving in the center, and St. Michael Archangel. The photograph below shows the reredos on the left closest to the altar. The figures left to right and top to bottom include Archangel Gabriel, Nuestra Señora de Guadalupe, and Archangel Michael; San Juan Nepomusceno, a large carving representing Jesús Nazareno clothed in a purple robe; St. Joseph with Christ Child on the right; and a c. 1980 carving of St. Anthony of Padua by Enrique Rendón on the left, and a c. 1978 carving of St. Francis of Assisi by Horacio Valdez, on the right. (Both, courtesy of Sons of the Holy Family.)

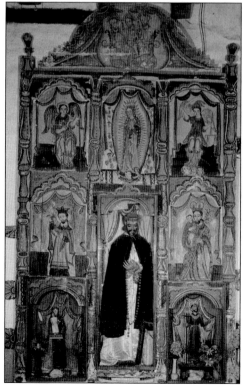

The School of Jose Rafael Aragon painted the reredos on the right as one enters the church (at right). The figures from left to right and top to bottom include St. Alyosius of Gonzaga, St. Joseph with the Child Jesus, St. Gertrude the Great. Bottom; St. Rosalie of Palermo, a carved image representing Our Lady of Solitude—attributed to Jose Rafael Aragon, and St. Clare of Assisi. Molleno painted the reredos on the right closest to the altar (below). Figures from left to right and top to bottom include an unidentified saint with a banner, the Cross of Esquipulas, Our Lady of Sorrows; St. Cayetano, a c. 1978 carving of San Cayetano by Alex Ortiz, and St. Francis Xavier. (Both, courtesy of Sons of the Holy Family.)

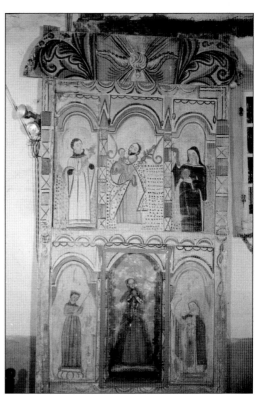

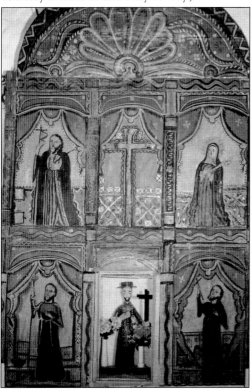

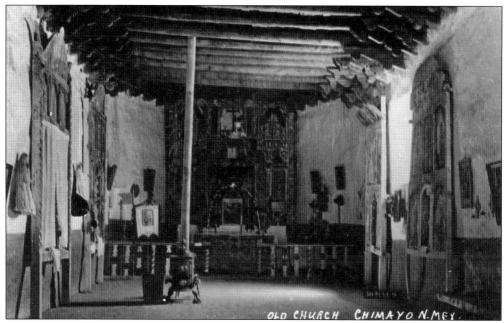

The interior of the Santuario chapel was decorated with reredos commissioned by Bernardo Abeyta and had a front altar with the crucifix of Our Lord of Esquipulas soon after it was built in 1816. The chapel was otherwise sparsely furnished. After Fr. Casimiro Roca was assigned as pastor of the Santuario in 1959, Masses were offered more frequently, and pews were necessary for people who attended Mass. Handmade pews were placed in the chapel. Photographs of the interior in 1941 (above) and 1979 (below) show this change. (Above, courtesy of Jake O. Trujillo family collection; below, courtesy of Holy Family Parish Archives.)

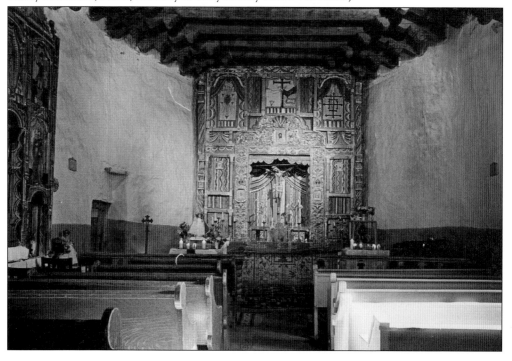

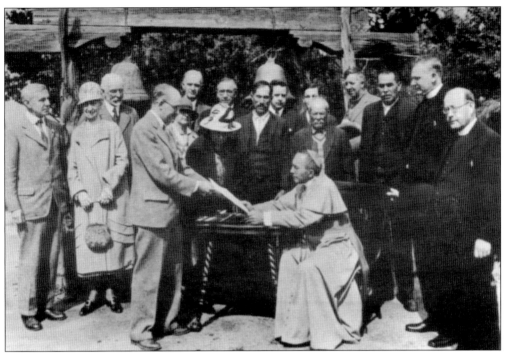

Financial hardship forced the three remaining members of the Chávez family to begin dismantling the chapel built by their grandfather Bernardo Abeyta. In 1929, an anonymous donor gave $6,000, through the Society for the Revival of Spanish Arts and the Society for the Restoration and Preservation of Spanish Missions of New Mexico, to purchase the property. The October 1929 photograph above shows architect John Gaw Meem as he delivers the Santuario deed to Archbishop Albert T. Daeger (seated) in the archbishop's garden. Those standing in the background are, from left to right, Paul A. F Walter, Dr. Francis Proctor, Alice Corbin Henderson, unidentified, E. Dana Johnson, Mary Austin, Gustave Bauman, Marcos Chávez, Daniel T. Kelley, Judge Charles-Fahy, Jose Chávez, Frank Applegate, Victor Ortega, Bishop Espalage, and Fr. Salvatore Gene. Around 1930, a pitched corrugated metal roof was constructed by Hermenejildo Jaramillo to protect against the mud-plastered walls deterioration by rain and snow. (Above, courtesy of Robert Ortega; below, courtesy of Palace of the Governors Photo Archives of the Museum of New Mexico, Negative 008901.)

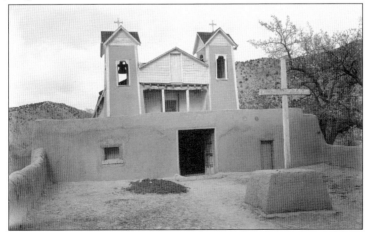

The earth around the Santuario was believed to have curative powers, even before the chapel was built. Bernardo Abeyta built a *hermita* (small shelter) to protect the actual site where he found the crucifix. The chapel was built to include the hermita, which is located next to the altar as part of the sacristy. This is the location of "El Pocito" (the little well), in which the healing earth is located. Here, thousands of pilgrims come to fill small containers with the dirt. This 1974 photograph shows the room where the *pocito* is located. (Courtesy of Sons of the Holy Family.)

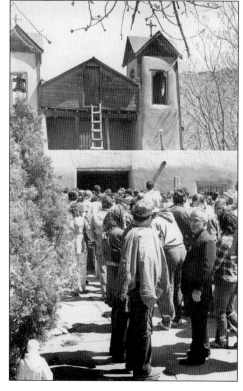

Pilgrims have always flocked to the Santuario de Chimayó, but numbers have increased significantly in recent years. In this 1980 photograph, several pilgrims wait to enter the chapel. Fr. Casimiro Roca, pastor of the Santuario since 1959, greets people as they wait to enter the chapel. (Courtesy of Holy Family Parish Archives.)

As more people visited the Santuario, changes were made to the grounds to accommodate the increased traffic. Visitors began to come from places farther away than Chimayó, and they would spend more time on the grounds. This required improving the infrastructure at the site, including the addition of parking lots, restrooms, and benches or other structures on which visitors could sit. The changes are visible in comparing the 1940 (right) and 1980 (below) photographs of the Santuario. The chapel itself has remained the same. (Right, courtesy of Jake O. Trujillo family collection; below, courtesy of Holy Family Parish Archives.)

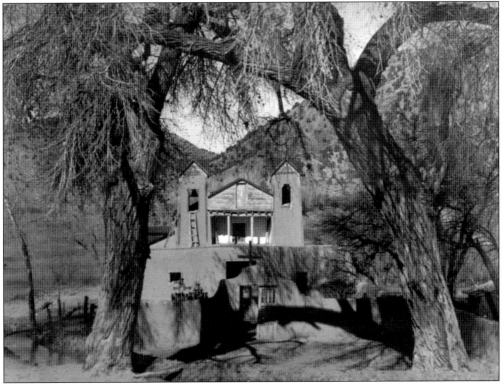

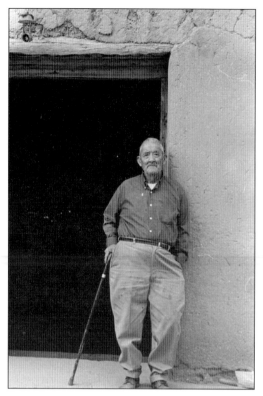

At left, Pablo Medina poses in front of El Santuario for a 1980 photograph; he was one of its caretakers for many years until his death in 1970. He made sure the chapel was opened every morning and closed every evening, and he assisted the priests who gave Mass. Fr. Casimiro Roca, S.F. (below), became pastor of the Santuario in 1959. Father Roca was instrumental in restoring the grounds behind the chapel to prevent the church structure from falling. He also restored the floor and installed pews in the chapel to allow more persons to attend Mass. In 1970, he was responsible for having the Santuario designated as a national historic landmark. Now retired, he served as a priest in Chimayó for over 50 years. (Left, courtesy of Holy Family Parish Archives; below, courtesy of Sons of the Holy Family.)

Three

FOLLOWING TRADITIONS

Those who settled in Chimayó followed many Spanish traditions that were passed down from ancestors, marking celebrations of important steps in life. These traditions were then passed to the generations that followed. Many were based on critical Christian rituals like baptism, First Communion, marriage, and death.

Feast days of saints were traditionally celebrated with a procession to the church featuring an icon of the honored saint carried at the lead. A Mass followed the procession, and then a fiesta began. People of the community gathered to eat favorite foods and listen and dance to music. Occasionally, depending on the season, folk plays or pageants commemorating a historical event were performed.

A popular tradition followed during feast day celebrations is the dance-drama of the matachines, an ancient tradition in the Hispanic Southwest and one of very few dances shared by both Hispanic and native peoples. The dance is said to have originated in medieval Spain in the 12th century or earlier as a pantomime of Moorish-Christian combat. Some Pueblos attribute the dance to a Mexican-Indian king identified as the figure of Monarca or Montezuma. According to Sylvia Rodríguez, author of *The Matachines Dance*, the story told by *los matachines* is that of "encounter, struggle, and transformation between light and dark forces."

Las Posadas are another long-standing tradition brought to New Mexico from Spain. This involves the reenactment of Mary and Joseph's entrance into Bethlehem and their quest for shelter before the baby Jesus was born. Joseph knocks on the door and asks if there is room at the inn. People from inside respond that there is none. Then the couple goes to the next door. Mary is mounted on a donkey as Joseph leads it. Finally, someone opens the door to and offers them a place to stay, and Christmas carols are sung and refreshments shared.

There are many Spanish traditions practiced by the people of Chimayó, but only a few are briefly mentioned in this book.

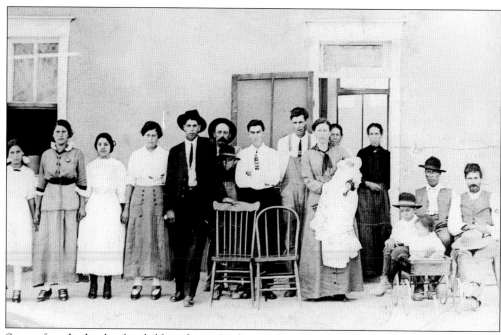

Soon after the birth of a child, *padrinos* (godparents) were chosen to help the parents with its spiritual and temporal needs. Arrangements were made for the child to be baptized by a priest who came on an occasional basis from Santa Cruz de La Cañada to serve the people of Chimayó. At the christening, the baby was given a litany of names taken from favorite saints. Baptism of a newly born child was viewed as a critical Christian virtue, as well as a joyous occasion for a fiesta. The c. 1915 photograph above shows the baptism of Ambrosio Ortega, with his parents and godparents posing with the rest of the family. The 1934 photograph below shows godparents Virginia Trujillo Ortega and Manuel Trujillo with baby Bertha Ortega posing with her father, Richard, after the baptism. Standing, from left to right, are Virginia Ortega, Manuel Trujillo with baby Bertha, and Richard Ortega. (Both, courtesy of Robert and Andrew Ortega.)

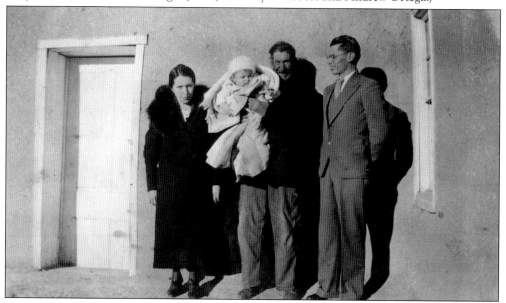

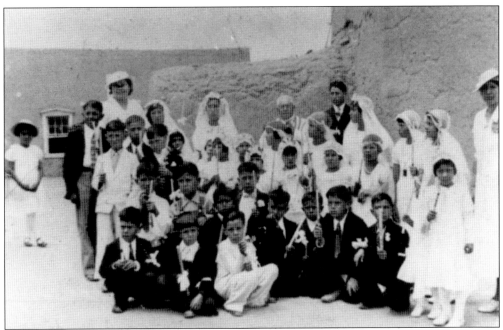

Photographs of first communicants together with their teachers were also common. In the c. 1922 photograph above, communicants are photographed in front of the Santo Niño Chapel. The teachers are Mercedes Trujillo (far right) and Martinita Ortega (far left). In the center background are Fr. José Teres, S.F., with acolyte Jacobo Trujillo, standing behind 30 communicants. In the 1959 photograph below, first communicants—from left to right, Michael Medina, Joe Martinez, Sennie Medina, Beraldo Montoya, and Leopoldo Montoya—are pictured in the Santuario courtyard with their teacher, Dominican Sister Mary Joaquin, who came from nearby Santa Cruz de La Cañada parish to teach catechism. (Above, courtesy of Jake O. Trujillo family collection; below, courtesy of Dennis and Leona Tiede.)

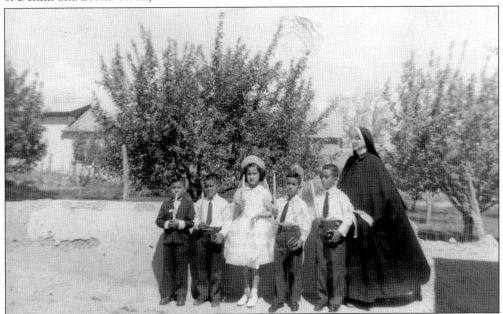

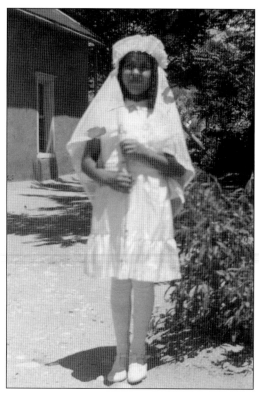

A First Communion was not only a tradition, but also one of the first major milestones in the life of every Catholic child in Chimayó. As such, it was an event to commemorate through a photograph. Dulcinea Trujillo (left) and Margaret Trujillo (below) were photographed in their First Communion dresses in their respective front yards. Note the typical architecture of the house behind Dulcinea and the Navajo weaving on which Margaret stands. (Left, courtesy of Dulcinea Vigil; below, courtesy of the Mercedes Trujillo collection.)

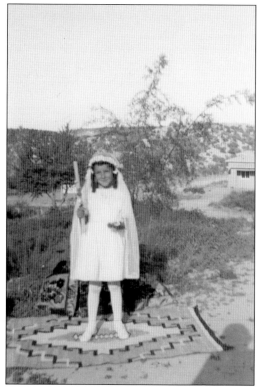

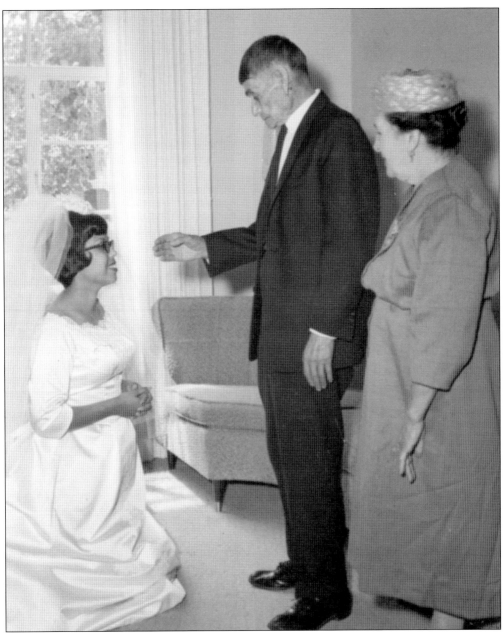

Due to Chimayó's isolated location, priests were a scarce resource for early inhabitants of the community. It became common for elders to give blessings to family members. Part of the extended family tradition in Chimayó includes having great respect for elders. Having been blessed with a long life, elders were revered as having wisdom and strong faith. A common family tradition was to "*pedir la bendición*" (ask for a blessing) from an elder of the family before retiring to bed or starting on an important journey. The benediction was a symbol of respect from the one asking for the blessing and well-wishing from the wise elder giving the blessing. In this 1985 photograph, Bertha Ortega kneels before her grandfather Nicasio Ortega, who is blessing her before her wedding, while her grandmother Virginia Ortega is at right. (Courtesy of Robert Ortega.)

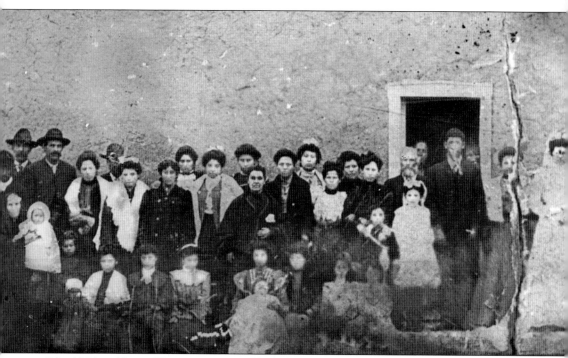

The 1904 wedding of Encarnación Trujillo and Eulogia Roybal was an extravaganza for its time, as evidenced by all the guests in the photograph. Weddings often lasted for two days and included lots of food, music, and dancing. At the wedding celebration, the bride and groom led the *Gran Marcha* (grand march), which turned into a waltz around the reception area. During the dance,

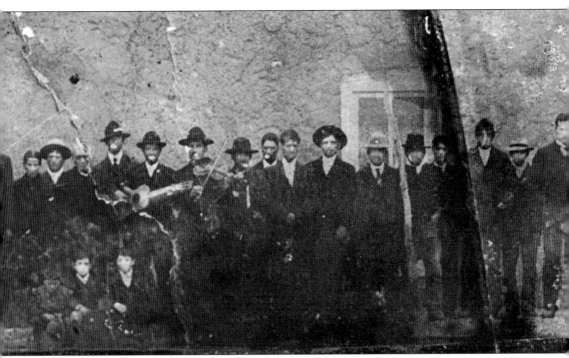

guests were invited to partake of the refreshments. This merriment often lasted for several hours, and sometimes the bride changed gowns two or three times during the dance. The celebration ended with the *entriega*, in which the best man and maid of honor presented the married couple to the parents. (Courtesy of Carlos Trujillo and Carol Alarid.)

A wedding was always a big event in Chimayó—an occasion for joy and feasting. Marriages were arranged by the parents, and the preparations followed a traditional protocol. The groom's parents and *padrinos* (best man and maid of honor) formally asked for the bride's hand in marriage. If she did not accept, the formal response was *dando calabazas* (giving the squash). If she did, a *prendorio*

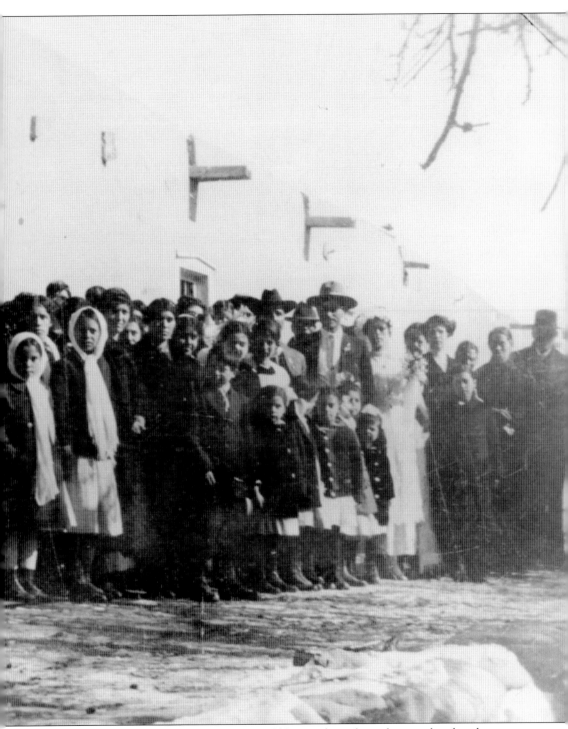

(engagement party) followed, and then a nuptial blessing from the padrinos, who placed a rosary over the neck of the bride and groom to be. This photograph shows the 1917 wedding of Severo Jaramillo and Teresita Trujillo at Santa Cruz de La Cañada. (Courtesy of Tim Cordova.)

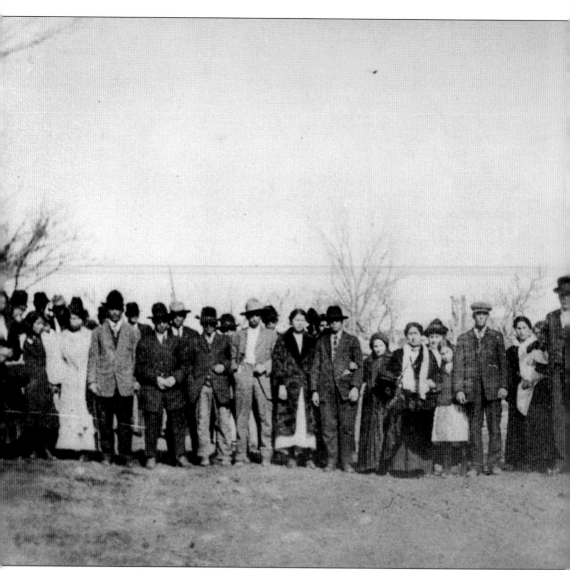

The 1915 wedding of Jose Manuel Vigil to Alfonsa Ortega was a big event for those days. At the engagement, a big trunk with the wedding trousseau was brought by the groom and presented to the bride. It often consisted of the long-trained, white satin gown, with all the accessories—veil, wax orange flower wreath, white shoes, gloves, a set of combs, other silk dresses, silk patterns with buttons and trimmings to match, and a set of jewels including the wedding ring. Usually,

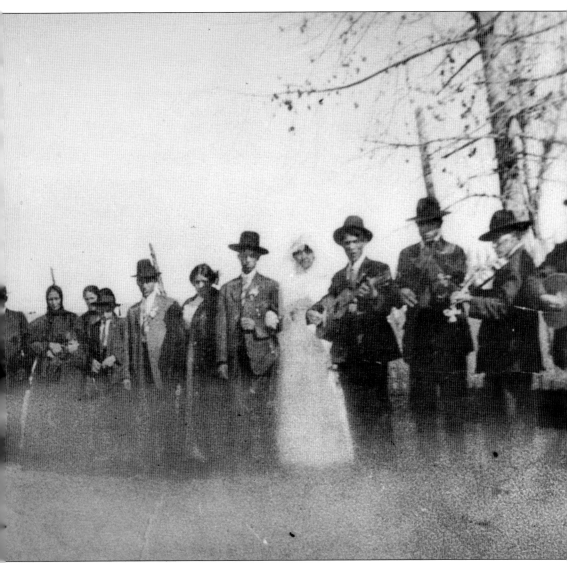

there was a pair of long pearl earrings and a round brooch to match. Preparations then began for the wedding. Wedding invitations, printed in the name of both parents and distributed by messengers, respectfully requested the recipient's presence and that of his family at the wedding and at the reception afterward. (Courtesy of Elma and Raymond Bal.)

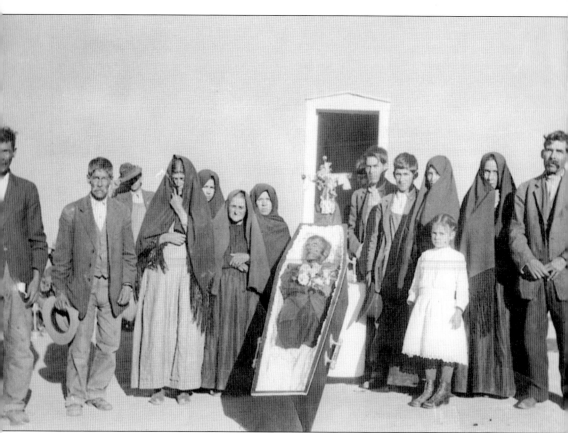

When people died, it was customary for the family to have a one- or two-night-long wake for the deceased, at which the family and neighbors would stand vigil and pray the rosary. Often, the Penitentes would sing *alabados* (sorrowful hymns) accompanied by a flute. The deceased was placed in an open pine casket for viewing as everyone paid last respects. The dead person was buried the next day after a long procession to the burial site. For weeks after the funeral, people called to offer sympathy to the bereaved, and the women dressed in black and wore black shawls. This 1926 photograph shows the funeral of Asención Martinez. His widow, Victoria, is standing with her hands crossed in the first row to the deceased's immediate right. The deceased's two sons, Apolonio and Enemecio, are to his left, together with his daughter Lucia, the girl in front. The remaining, unidentified persons are probably other relatives. (Courtesy of Mickie Medina.)

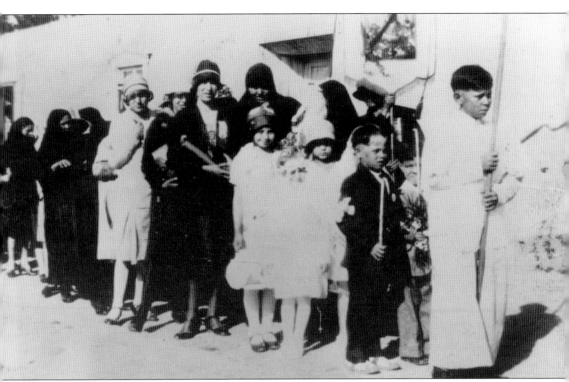

Processions were common, especially for religious feast days or special occasions. Processing to a sacred place was like a short pilgrimage to reflect on the occasion and/or the life of the saint or personage being honored. This 1922 photograph shows a procession of First Communicants and Carmelitas from the Oratorio de San Buenaventura to the Santo Niño de Atocha Chapel, where the children would make their first Holy Communion. Leading the procession with a cross is Rosinaldo Trujillo, who is followed by communicants Ernesto Martinez, and Ricardo Martinez. Elena Jaramillo, Leonardita Trujillo, and Josefina Vigil are behind them in white dresses. Their teachers, Teresita Jaramillo and Mercedes Trujillo, are immediately behind them along with unidentified members of Las Carmelitas. As they processed, the rosary was prayed and alabados were sung. (Courtesy of the Chimayó Museum.)

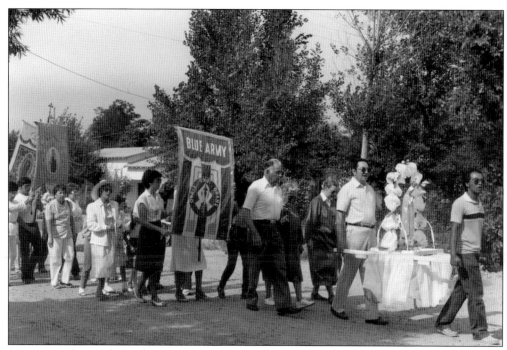

Processions during el Mes de María (the month of Mary—May) are intended to honor Mary as the Mother of Jesus. In addition to praying the rosary as they processed, people sang songs in honor of Mary. The 1988 photograph above shows a group of unidentified people carrying banners of the Blue Army, Nuestra Señora de Guadalupe, and Nuestra Señora del Carmen and following the image of Mary on a carrying litter while processing from the Santuario to Holy Family Church in Chimayó. The photograph below shows the same procession but has a broader view along the route and includes the unidentified leader and altar boy carrying a crucifix directly in front of Fr. Jose Maria Blanch, S.F.; Minnie Vigil; Fr. Miguel Mateo, S.F.; an unidentified boy; and the image of Mary followed by unidentified members of groups from Chimayó with their banners. (Both, courtesy of Holy Family Parish Archives.)

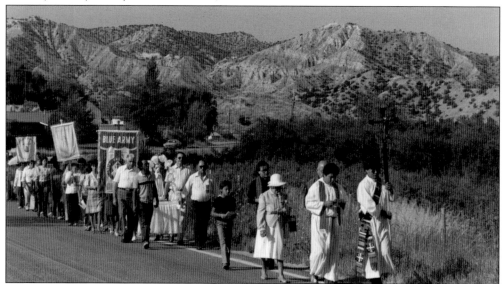

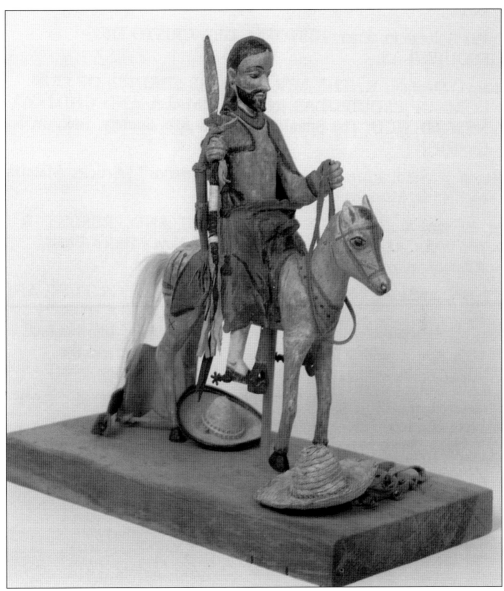

St. James the Evangelist is one of the most significant saints to the people of Chimayó. He is depicted as a man on horseback in a bulto called *El Señor Santiago*. The July 25 Feast Day of St. James (Santiago) has been celebrated in Chimayó for many years as the Santiago Fiestas, when an image like the one shown here was carried in processions. St. James legendarily led the Christians in Spain to victory against the Moors. This particular bulto in the photograph was made in the mid-1800s but has been broken several times. In 1955, Alan Veddar, from the Spanish Colonial Arts Society, restored it to its present state and placed in a glass case for protection. (Courtesy of Holy Family Parish Archives.)

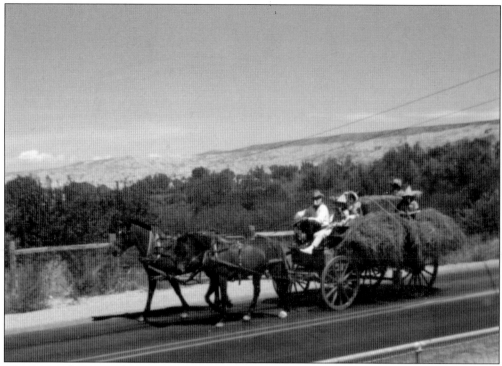

The national patron of Spain, Santiago, a folkloric hero depicted riding a white horse, is also a popular patron in Chimayó. It is traditional to parade on horseback on the feast day of Santiago, and for him to bless the fields. In the 1961 photograph below, unidentified horsemen parade their horses on Día de Santiago (Santiago feast day) on the road toward the Santuario. In 1968, a Santiago Day parade included a horse-drawn hay wagon that was sponsored by Centinela Ranch as a "Hayride to the Santiago Fiestas." The photograph above shows members of the Trujillo, Archuleta, and Cordova families riding from La Centinela to the fiesta at the Santuario. (Above, courtesy of Holy Family Parish Archives; below, courtesy of Jake O. Trujillo family collection.)

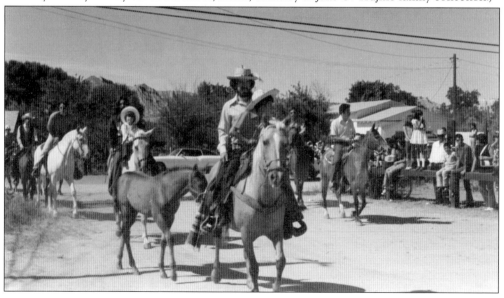

One of the ways a sense of community was created in Chimayó in the 20th century was through the celebrations of the Feast Day of St. James at the Santiago Fiestas. Many families volunteered to run food booths during the celebration. Entertainment was provided so that people would spend time at the fiesta communing with their neighbors. The 1961 photograph above shows a food booth sponsored by the Archuleta family—Margaret (left), Gloria (center), and Helen Archuleta. An old-timey dress-up contest was held during the fiestas in 1960. The photograph below shows young girls lined up for costume judging. (Both, courtesy of Holy Family Parish Archives.)

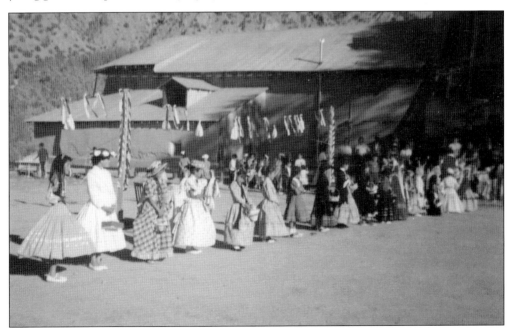

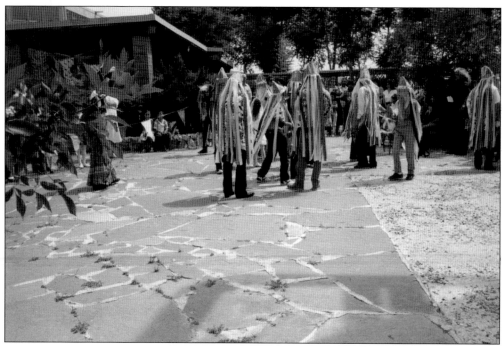

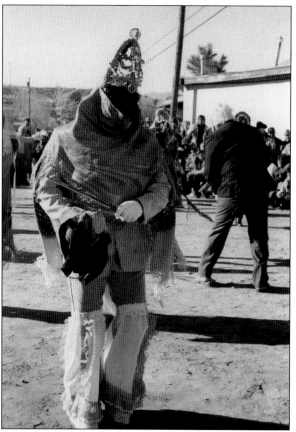

Los Matachines were commonly performed as entertainment during the Santiago fiestas. A fiddle and guitar provide music to accompany the dancers. In the 1988 photograph above, matachines prepare to dance during the Santiago Fiestas at Holy Family Church. The heads of the matachines are surmounted by tall headdresses made of fabrics such as velvet and silk, and are decorated with silk ruffle borders and jeweled trinkets and symbols. The 1988 photograph at left depicts a matachin as he performs a dance during the Santiago fiesta at the Santuario. (Above, courtesy of Holy Family Parish Archives; left, courtesy of Jake O. Trujillo family collection.)

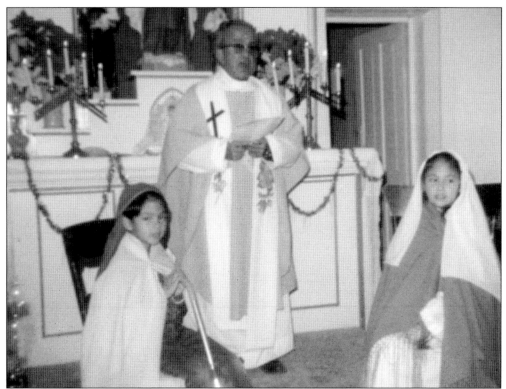

This 1987 image, taken at La Cuchilla Capilla del Carmen (Chapel of Our Lady of Mount Carmel), shows two children playing Mary and Joseph in front of Fr. Casimiro Roca after a Mass celebrating Las Posadas just before Christmas Day. (Courtesy of Holy Family Parish Archives.)

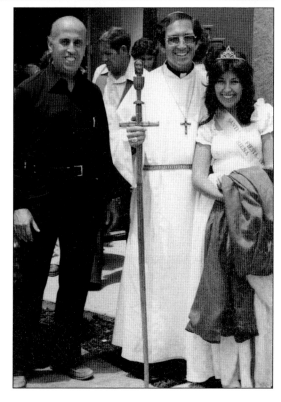

Celebrating Santiago fiestas in Chimayó was an occasion important enough for a visit from the archbishop. In this 1988 photograph, Fr. Jose Maria Blanch, S.F. (left), poses with Archbishop Robert Sanchez and the Santiago Fiesta Queen. (Courtesy of Holy Family Parish Archives.)

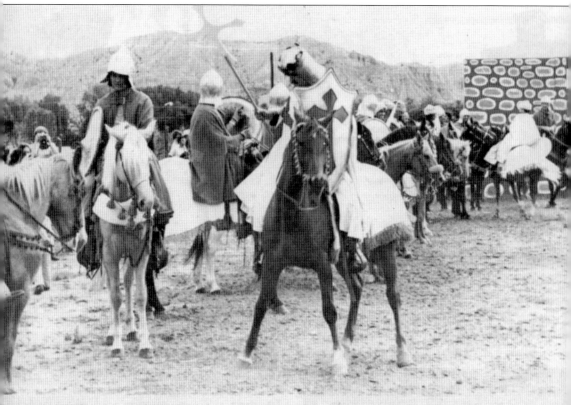

ers prepare to perform the symbolic last battle between the Spanish and the Moors in the old Spanish drama.

rama to re-enact Spanish conquest of Moors

The Moros y Cristianos (Moors and Christians) folk pageant was presented during the Santiago Fiesta on July 25, 1980, to commemorate the Spanish reconquest of Spain from the Moors. In the year 844, the emir of Córdoba demanded a tribute of 100 virgins from the king of Asturias. The Catholic king refused and decided to do battle. The night before the battle, Santiago appeared in a dream to the king and told him not to fear, as he would be with him. The battle was won by the Christians, and no tribute was paid. The play originated to keep these military adventures of Santiago alive. The traditional reenactment of the battles on horseback has been performed on the feast day of Santiago since the time of Don Juan de Oñate, in 1598. (Courtesy of the *Santa Fe New Mexican*.)

Four

WEAVING AND WEAVERS

The first settlers of Chimayó introduced Churro sheep to the area. Weaving began as a necessity to make cloth known as *sabanilla, jerga* (rugs) for the floor, and *frasadas* (blankets) to keep warm. The Ortega and Trujillo families were the first weavers in Chimayó, and their descendants continue the weaving tradition.

Chimayó weavers carded and spun their own yarn on hand spindles and spinning wheels. Different thicknesses of yarn were spun from the raw wool, which was made into a ball and later into hanks or skeins. The hand-spun wool was then washed. Yucca roots, also called amole, were crushed and dried and then placed in water to wash the wool. Yarn was washed two or three times in the amole bath and then rinsed and dried.

Homespun blankets were created with three basic colors of wool woven in stripes. Early weavers learned to dye the wool to obtain colors that varied from the natural sheep's wool. Caravans from Mexico brought dyestuffs that produced bright colors and weavers who introduced techniques to weave intricate designs. Various plants found in the area were also used to create dyes. Woven blankets could be traded for goods that came on the Camino Real from Mexico and on the Spanish trail going toward California.

The Chimayó blanket was developed for the curio trade using design elements from the Saltillo serape from Mexico and simple elements like stripes, chevrons, and small trapezoid designs from early utilitarian weavings. The first dealer of Chimayó blankets was Reyes Ortega. Nicasio Ortega established the first weaving shop in 1918. Other weavers from the Trujillo family sold directly from their homes, establishing a cottage industry in Chimayó.

Over the past 100 years, Chimayó has gained international renown as a center of Hispanic weaving. The first recorded weavers in the Ortega and Trujillo families of Chimayó were Nicolas Grabiel Ortega and Diego Trujillo, who began unbroken lineages of weavers that now include eight generations.

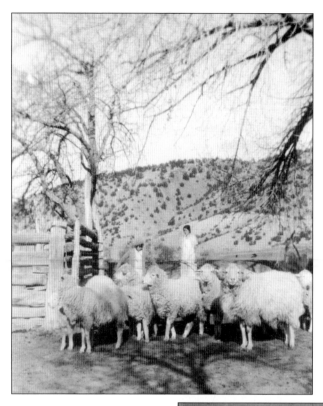

The first settlers of Chimayó brought Churro sheep, a hardy breed ideal for meat and with a long staple length of wool with relatively low grease content, making it ideal for spinning. As other breeds became available, Churros were crossed with Rambouillet and Merino sheep for weaving wool. Weavers often raised their own sheep, and this 1931 photograph shows Teresita Trujillo Jaramillo (right), with her daughter Elenita, herding sheep to the corral. (Courtesy of Tim Cordova.)

Sheep were shorn every spring before lambing, and the fleeces were then skirted to remove unwanted organic material. Wool from Churro sheep has a long staple length for spinning and a natural luster. Wool from sheep of Rambouillet mix generally had more grease, and after skirting, it was put in the sun to melt off the grease. Scouring the fleeces with amole from the yucca plant root, followed by drying, made the wool ready to spin and dye. In this 1990 photograph, Juan Jaramillo, from Las Vegas, New Mexico, hand-shears a Churro ewe at La Centinela. (Courtesy of Marco A. Oviedo.)

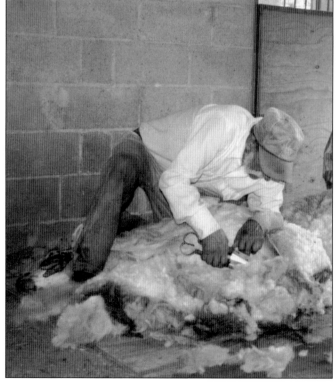

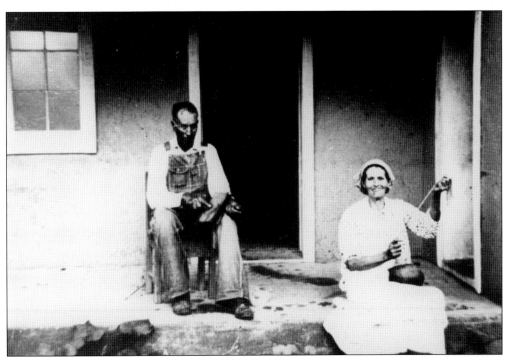

Chimayó weavers carded and spun their own yarn on hand spindles and spinning wheels. Different thicknesses of yarn were spun from the raw. Skeins of white wool could be dyed with natural vegetable dyes. In this 1935 photograph, Isidoro Trujillo and his wife, Francisquita, are carding and spinning wool. (Courtesy of the Jake O. Trujillo family collection.)

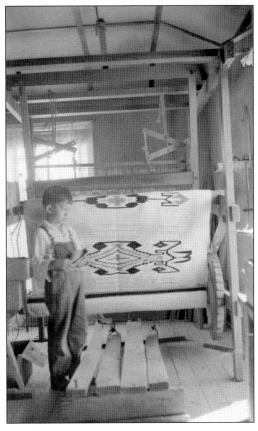

A horizontal treadle loom, made of thick hand-hewn wood beams or rough-cut lumber, was used to weave Chimayó blankets. This 1936 photograph shows a typically constructed loom used by Severo Jaramillo. Luisito Trujillo is standing next to the loom, which holds a weaving with a Chimayó design. (Courtesy of Tim Cordova.)

The original simple utilitarian textile evolved somewhat in design into a striped blanket called a Rio Grande style, as displayed in the left photograph of a 1970 weaving by Irvin Trujillo. In 1807, Juan and Ignacio Bazaan, from Saltillo, Mexico, were contracted by the government of New Mexico to train weavers in northern New Mexico. They introduced production organization and techniques to weave complex patterns, as shown in the Saltillo blanket below, an 1850 product by an unknown weaver. The Chimayó blanket combines the design elements of both Rio Grande and Saltillo styles. (Both, courtesy of Irvin Trujillo.)

The influences of the Rio Grande style and the Saltillo style, in combination with the weaver's own imaginative artistry, make an irreproducible work of art. A Moorish influence from Spain, together with southwestern Native American influence in the woven symbols, can also be seen in designs characteristic of Chimayó blankets. Descendants of the early weavers were and remain masters in their own right and continue expressing themselves through the weaving of Chimayó blankets, which have become world-renowned. Blankets woven by Teresita Trujillo Jaramillo in 1950 (right) and in 1980 by Dimas Vigil (below) show typical design elements that make a Chimayó blanket. (Both, courtesy of Tim Cordova and Dulcinea Vigil.)

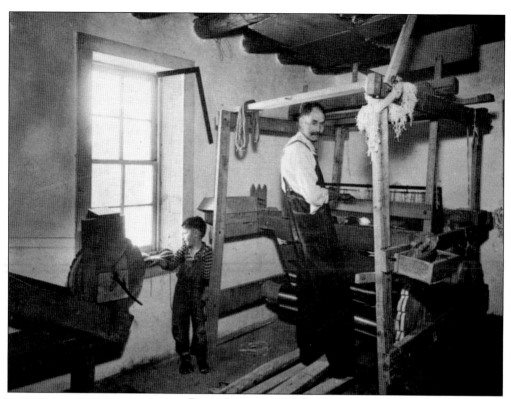

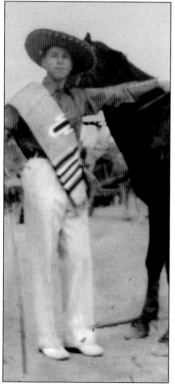

Reyes Ortega and his brothers learned to weave from their father, José Ramón, and their entry into the market in the early 1900s was inspired by Sito Candelario, a Santa Fe curio-shop owner who sought connections with Chimayó weavers. Ortega was a skilled weaver and successful businessman, but he had no male heirs, so his business closed upon his death. In the c. 1939 photograph above, Reyes is weaving at the loom. Advertising the weavings was mainly done via postcards. In the 1931 postcard photograph at left, Jake O. Trujillo poses with a Chimayó weaving on his shoulder. (Above, courtesy of Don Usner; left, courtesy of Irvin Trujillo.)

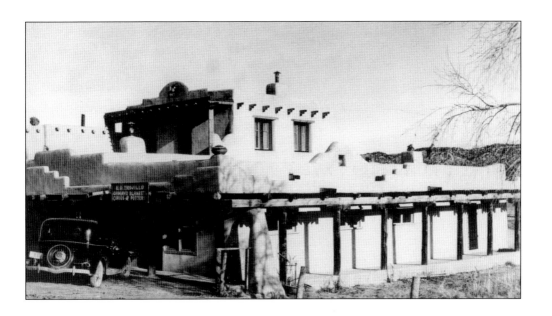

Before weaving shops were stand-alone commercial establishments, weavers often sold from their homes, creating a viable cottage industry. In 1917, E.D. Trujillo opened a general store in his home in El Rincón de Los Trujillos (pictured above) and began selling weavings from there. Many dealers followed suit, as shown in the 1937 photograph below, in which Severo Jaramillo (right) stands in front of his house with tourists and blankets that they had just purchased from him. As tourism grew and brought more visitors to Chimayó, the weaving business grew to meet consumer demand. (Above, courtesy of the Chimayó Museum; below, courtesy of Tim Cordova.)

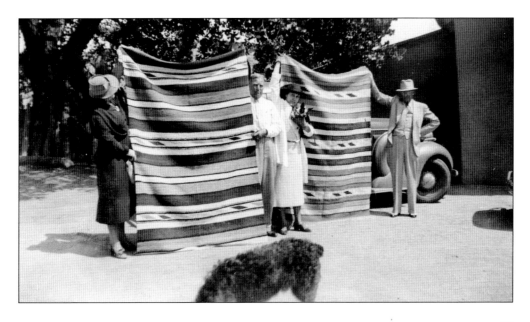

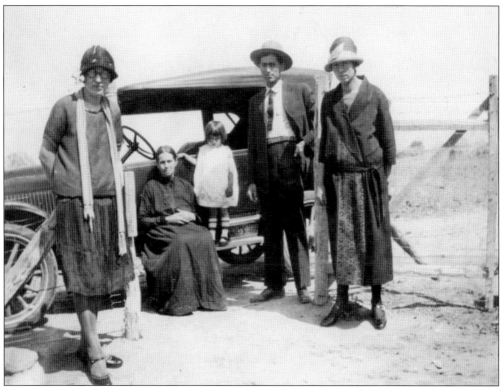

The availability of cars made it possible for blanket dealers to go out of Chimayó to other parts of northern New Mexico and southern Colorado. Pictured in the 1926 photograph above are, from left to right, Mercedes Trujillo; Severo Jaramillo's mother, Epimenia Ortega Jaramillo; Severo's daughter Elenita; Jaramillo; and Jaramillo's wife, Teresita, as they prepare to go to Santa Fe to sell blankets. The photograph below shows Nicasio Ortega (left) with two unidentified helpers as they take a break to eat watermelon during a trip to sell blankets in 1922. (Above, courtesy of Tim Cordova; below, courtesy of Robert and Andrew Ortega.)

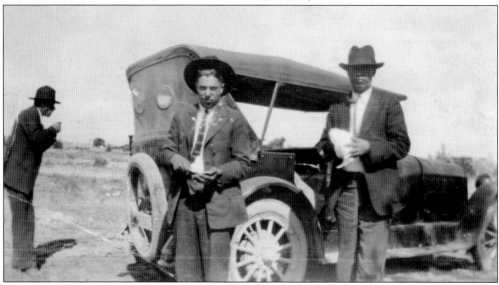

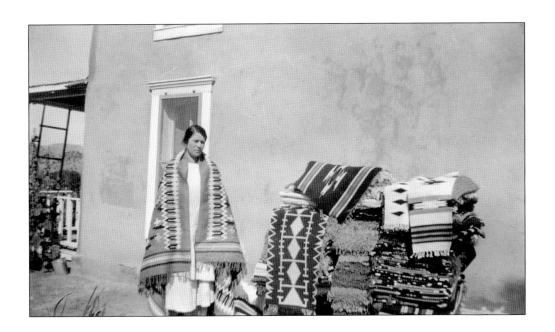

The 1930 photograph above shows Teresita Trujillo Jaramillo standing in front of her home with blankets that her husband, Severo, had for sale. Photographs like this, usually made into postcards, were used to market the weavings. The construction of state roads made it possible for tourists to stop at weaving shops in Chimayó to buy blankets. In the photograph below, unidentified tourists from Kansas pose with Mercedes Trujillo, Teresita's sister, and a Chimayó blanket that they bought from Severo's store and that she had woven in 1952. (Both, courtesy of Tim Cordova.)

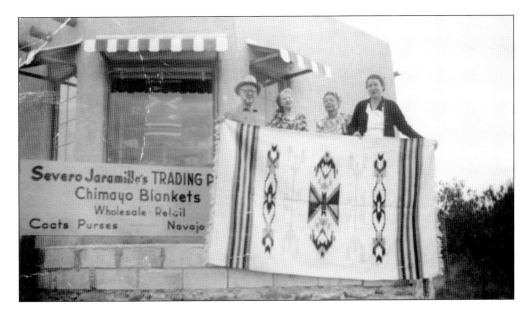

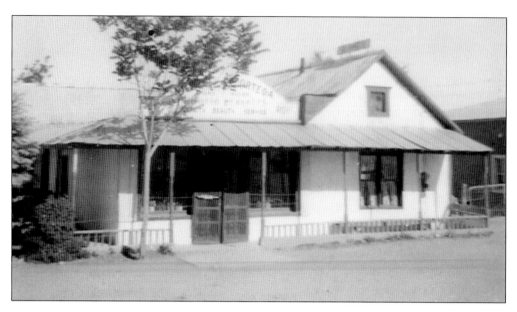

In response to the growth of tourism, the number of Chimayó weaver/entrepreneurs increased. According to Lucero and Baizerman's book *Chimayó Weaving: The Transformation of a Tradition*, their keen business abilities earned them a reputation as "Spanish-American go-getters." Nicasio Ortega opened the first weaving shop in Chimayó in 1918 and was joined shortly thereafter by Severo Jaramillo, Reyes Ortega, and E.D. Trujillo. The photograph above shows Ortega's weaving shop in 1940. Jaramillo opened a gas station/curio store in Chimayó in 1922, where he wove and sold Chimayó weavings. The photograph below shows Jaramillo (left) standing in front of his station with an unidentified neighbor. (Above, courtesy of Robert Ortega; below, courtesy of Jake O. Trujillo family collection.)

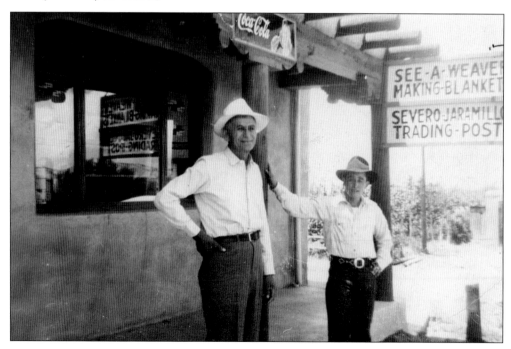

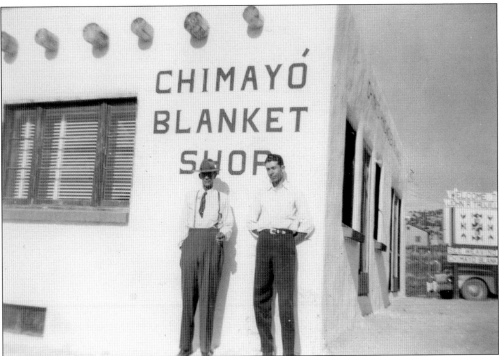

In the above picture, John Roybal Trujillo (right) stands with his father, Encarnación Ortega Trujillo, in front of the weaving shop he opened in 1950 after returning from World War II. In the photograph below, John Trujillo stands in front of the weaving shop—he had changed the name to El Chimayó Blanket Shop—in 1955 with his wife, Matilde, as they pose for a postcard photograph. Today, the shop is run by his son Carlos and daughter Carol and is called Trujillo's Weaving Shop. (Courtesy of Carlos Trujillo and Carol Trujillo Alarid.)

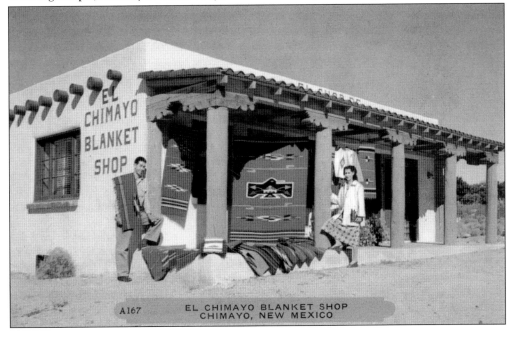

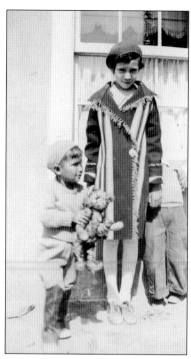

Santa Fe shop owner Julius Gans introduced new uses for Chimayó weavings and had the first Chimayó jacket designed in 1930 by Ollie McKenzie. In this 1933 photograph, Elena Jaramillo, daughter of Severo Jaramillo, models one of the first Chimayó jackets; Luisito Trujillo stands next to her. (Courtesy of Tim Cordova.)

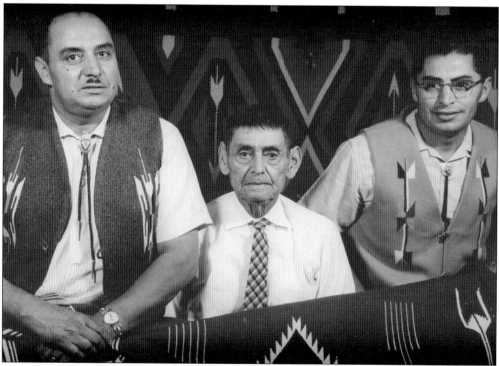

Postcard advertising was the most effective in the early 1960s. A 1958 photograph taken by photographer Maurice Eby, which was used as a postcard, shows Nicasio Ortega with his two sons, Jose Ramón (left) and David, who wear Chimayó vests; Nicasio sports a woven tie. (Courtesy of Robert Ortega.)

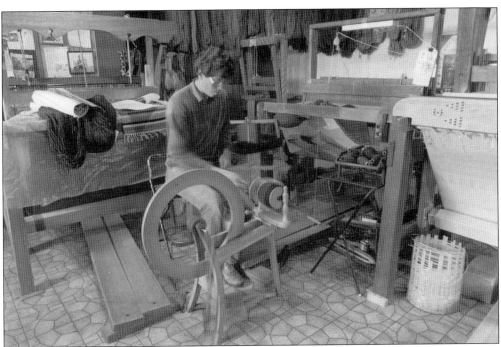

Weaving became a traditional pastime and has been carried on for generations. An example of this trend is Irvin Trujillo, pictured as he spins wool in the above image from 1986. Irvin, son of master weaver Jake O. Trujillo, is a seventh-generation weaver in the Trujillo-Ortega family. In the 1957 photograph below, taken by E.P. Haddon, Nicasio Ortega looks on as his grandson Alan learns how to weave. They represent two of eight generations of the Ortega family that have woven traditional Chimayó blankets. (Above, courtesy of Irvin Trujillo; below, courtesy of Robert and Andrew Ortega.)

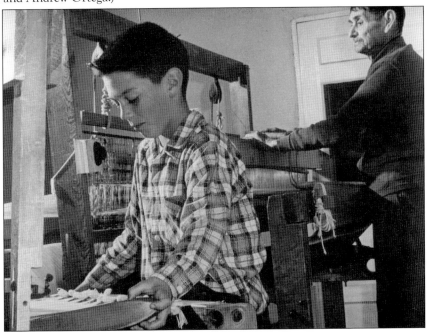

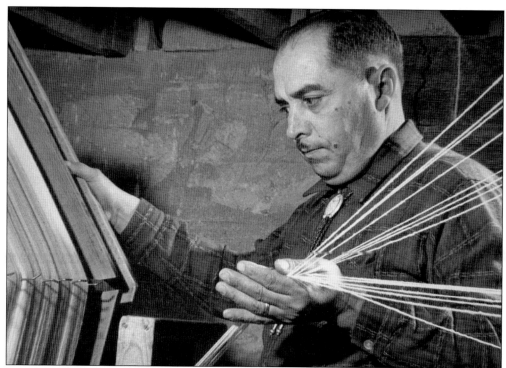

Preparing the warp to set up a loom and making spools of yarn to weave are both necessary steps before weaving can begin. Once the warp is made, it is strung onto the loom. In the 1970 photograph above, José Ramón Ortega is pictured making a warp. Below, in a 1935 postcard photograph, Jake O. Trujillo is making spools from skeins of yarn. The spools can be individually used to weave small designs or in a shuttle to weave one color of wool. (Above, courtesy of Robert Ortega; below, courtesy of Irvin Trujillo.)

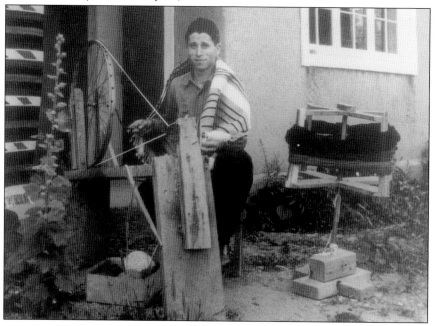

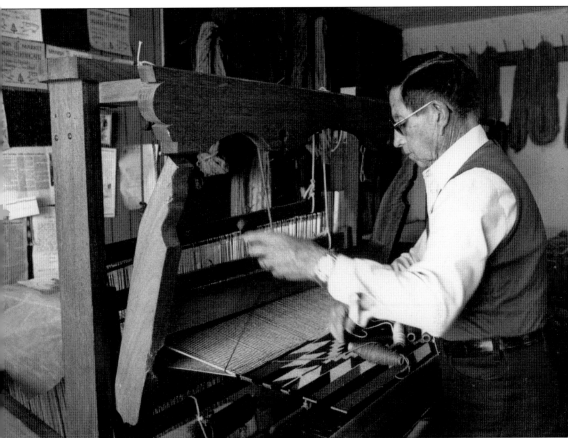

Jake O. Trujillo learned to weave from his mother, Francisquita Ortega Trujillo, and started out working for his brother-in-law Severo Jaramillo. He also taught weaving in Española and El Rito schools. During World War II, he enlisted in the US Navy and was stationed at Treasure Island as an instructor at the rehabilitation center, where he taught weaving and other crafts. After the war, he returned to New Mexico and worked at Los Alamos National Laboratory. He retired in 1975 and is pictured here in 1986, after he returned to weaving full-time at his loom in Chimayó. He opened Centinela Traditional Arts with his son Irvin and Irvin's wife, Lisa, in 1982. Irvin and Lisa continued the weaving tradition and still operate the shop today. (Courtesy of Irvin Trujillo.)

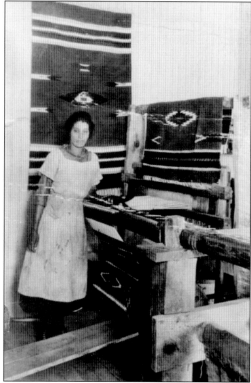

In order to increase production and maintain inventory, Chimayó blanket dealers would contract other weavers from their extended families to weave for them. The contract workers would pick up yarn from the dealers and bring back blankets. The 1978 photograph above shows Noberto and Elena Vigil, who were contract weavers for the Ortegas for many years. Luisita Trujillo, Nicasio Ortega's sister-in-law, is pictured at left in an image from Lester Griswold's 1942 book about Spanish weaving, *Handicraft*. This photograph was made into a postcard to market Ortega's Chimayó blankets. (Both, courtesy of Robert Ortega.)

Teaching the next generation how to weave has always been important. Children were first taught weaving-related tasks like carding and spinning, gathering dye plants, and filling spools with yarn for the shuttles. Later, when they were tall enough, they joined their parents or elders at the loom to learn basic weaving techniques like making a design, keeping the proper tension to weave straight edges, and combining colors. The 1980 photograph at right shows Dimas Vigil (background) teaching his younger cousin Eugene Vigil how to weave. The 1987 photograph below shows Jake O. Trujillo teaching the basics of weaving to his grandson Jacobo Oviedo. (Both, courtesy of Dulcinea Vigil and Jacobo Oviedo.)

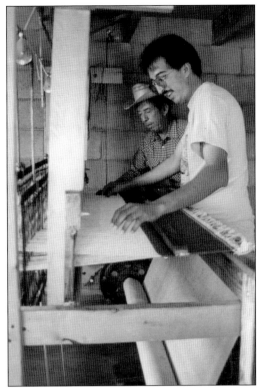

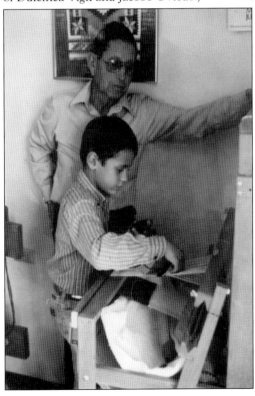

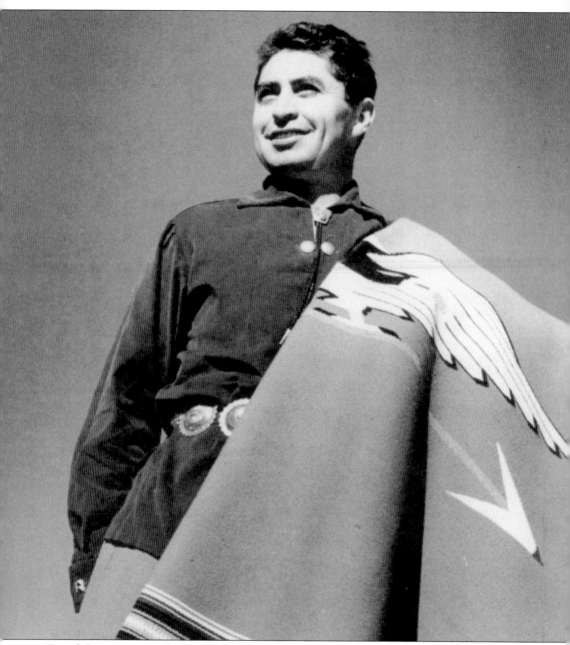

David Ortega, pictured around 1950, learned to weave from his father, Nicasio. After World War II, David joined his father and brother José Ramón to help save the family business, which had deteriorated during wartime because of the shrinking tourist market. After remodeling the store—adding a new front room and closing the grocery business—and primarily devoting the shop to weaving, David instituted some important changes. He added jackets, coats, and vests to the inventory and substituted more durable wool warp for cotton carpet warp, allowing them to market Ortega's weavings as 100-percent wool. Following the deaths of both Nicasio and José Ramón, David recruited his sons into the family enterprise. After more than 50 years in the business, he retired and passed the shop on to Robert, one of his four sons. (Courtesy of Robert Ortega.)

Five

CHIMAYÓ CHILE

Chiles have always been one of the most important crops grown is Chimayó. They were not only used as food, but also folk medicine. Chiles were introduced to the American Southwest by the Spanish, who brought them from Mexico on a trade route known as the Camino Real. Although there is good evidence of pre-Hispanic contact among Indians of the Southwest, there are no indications of pre-Hispanic use of chile peppers north of the border. The closest region to the American Southwest where chiles were found prior to Spanish settlement was near Casas Grandes, Chihuahua, Mexico. The plant's reputation in Chimayó goes back almost 150 years, when local farmers began bartering produce with Spanish settlers in the San Luis Valley of Colorado. The San Luis residents bartered wheat, beans, and potatoes for the cherished Chimayó chile.

In addition to its blankets and the Santuario, Chimayó has long been known for its red chiles. During the fall harvest, red chiles were picked, the peppers tied and strung to make *ristras* (strings of chile), and then hung to dry. After drying, the stems and seeds were removed from the pods, which were then ground to make chile powder. Chimayó chile is best known for being mild but flavorful, although the small size and thin skin make it harder to process when it is green.

During the Great Depression, chile became a means of obtaining goods from retail outlets in Española. About 60,000 *ristras* were traded in stores in Española in the 1930s. Every family in Chimayó grew most of their own food, but they devoted one-third of the land under cultivation to chile, producing enough of a surplus to bring the extras to market. Not all chiles produced in Chimayó went to markets; the townspeople consumed large quantities of chiles, both red and green, which were dried and stored for winter.

As Chimayó chile declined in commercial importance, it rose in culinary stature due in large part to the Rancho de Chimayó restaurant. The restaurant was one of the first anywhere to employ chile in almost every main dish, and the kitchen has always featured local chile when it has been available in sufficient supply.

Today, Chimayó maintains some of its connection to its agricultural past. It is the home of a famous "heirloom chile," *capsicum annuum (Chimayó)*, which is cultivated in Chimayó by several growers who are working to maintain traditional seed stock.

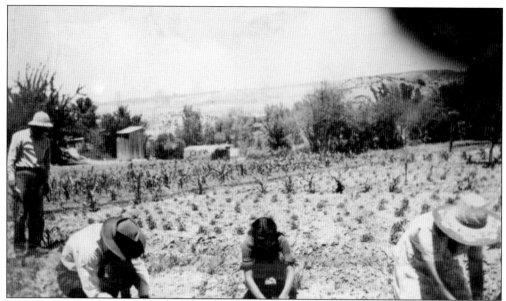

Growing chiles required much work, starting from the preparation of the soil, planting seeds, hand cultivating with a hoe, thinning, supporting each plant with dirt, irrigating many times throughout the season, and hand-picking. Often, several chile seeds were planted together to improve the chance of germination and later thinned out after the plants sprouted. The 1950 photograph above shows Frank Medina and his children hand-thinning chile plants near the Santuario in El Potrero. In the 1990 photograph below, Mercedes Trujillo holds a hoe in the midst of her chile field, checking her crop as she irrigates. (Above, courtesy of Dennis and Leona Tiede; below, courtesy of Don Usner.)

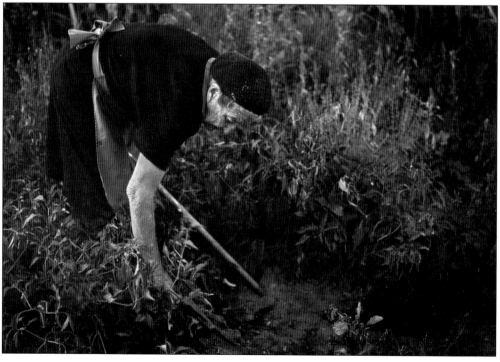

Other vegetables were planted together with chiles. In the fall, it was not unusual to see ristras of red chile and pumpkins or other produce harvested at the same time. The 1960 photograph above shows Simodosea Atencio Martinez, from the Plaza Abajo, standing in her chile garden and cornfield as she prepares to start harvesting the produce. If not used for the household, produce was made available for sale directly from the home or taken to markets in nearby towns. The 1960 photograph below shows a display of chiles and pumpkins for sale that were grown by Ralph Trujillo of La Centinela. (Above, courtesy of David Martinez; below, courtesy of Lindsey Trujillo.)

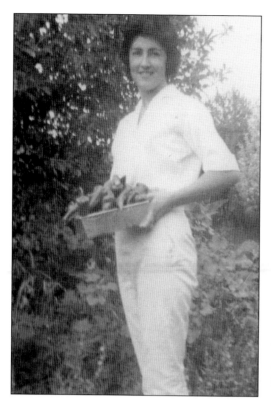

The time between planting and harvesting chiles was about three months. Once the green chile pods were firm, they could be picked to be roasted and peeled and either dried or frozen. As the growing season approached late summer or fall, the green pods began to turn red, making them ready to pick for tying into ristras to be hung out to dry. In this 1950 photograph at left, Mickie Martinez Medina holds green chiles, and in the 1967 photograph below, her father, Enemecio Martinez, stands in the chile field with both green chiles and bushels of red chiles. (Both, courtesy of Mickie Medina.)

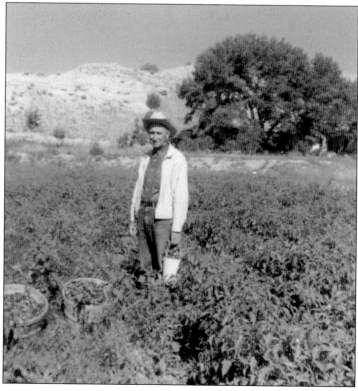

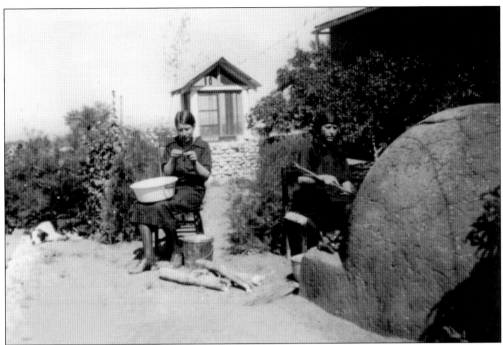

Traditionally, green chiles were prepared for cooking by roasting the peppers in the hot coals of a mud-brick oven (*horno*) and then peeling off the scalded skins. Stems and seeds were discarded, and the flesh of the roasted chile was either dried in the sun or, more recently, chopped and placed in plastic bags for freezing. The 1926 photograph above shows Teresita Trujillo Jaramillo roasting green chiles in the horno as her sister Mercedes Trujillo peels a freshly roasted chile. In the 1953 photograph below, Celestina Jaramillo Martinez shows her grandchildren how to peel roasted chiles. (Above, courtesy of Tim Cordova; below, courtesy of Carlos Trujillo and Carol Trujillo Alarid.)

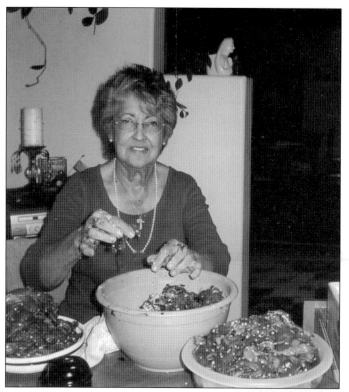

Green chiles were most commonly dried after roasting and peeling. When freezers became available for household use, freezing the roasted and peeled green chile became the preferred manner of storage. Green chiles that were frozen and thawed later had a taste similar to freshly roasted chile. Preparing the green chiles for drying or freezing is a tedious process. The left photograph shows Mickie Medina peeling freshly roasted green chiles. After the pods are roasted, the skin is peeled off by hand, and the stems are removed. In the photograph below, bowls of peeled chiles are ready for further processing and storage. (Both, courtesy of Mickie Medina.)

Red chile peppers were preserved by tying and weaving them into strings five to six feet long for drying. Sacks or bushels of red chiles were picked and piled in an area where they could be tied. Chiles were tied three pods at a time, then a string of these was woven onto a long twine. To motivate those tying the chiles, a watermelon was often placed at the bottom of the pile as a prize for tying all the chiles on top of it. In the 1943 photograph at right, Lucia Martinez Fresquez (right) and her helper Doña Cruz sit in front of a pile of chile, tying the pods into ristras. The ristras were then hung to dry in the sun between two posts or under the eaves of the house. Ristras could be single strands about five feet long, or bent in the middle to have two double strands, each six feet long. The 1964 photograph below shows Enemecio Martinez with both single and double chile ristras. (Both, courtesy of Josie Martinez.)

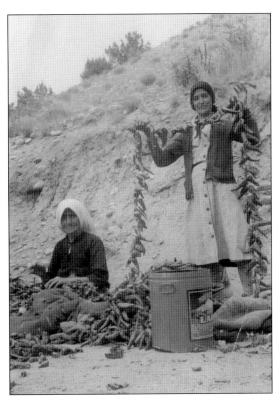

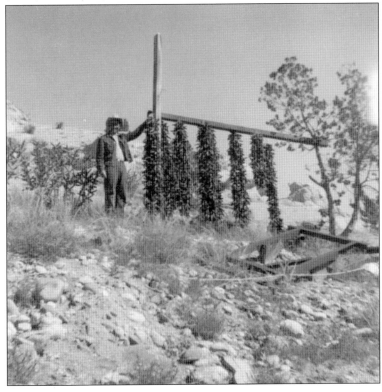

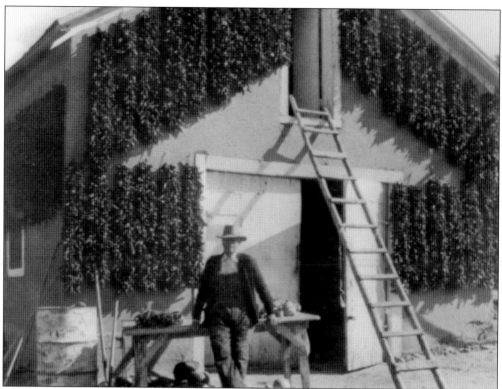

Chile ristras became a means of obtaining goods from retail outlets in nearby Española. In the 1943 image above, Isidoro Ortega Trujillo, of La Centinela, is shown in front of the storage building where he has hung several chile ristras that he planned to sell. About 60,000 ristras were traded through stores in Española in the 1930s, and the price per ristra ranged from 35¢ to $1. In the 1960 photograph below, Esquipula Martinez (left) and his son Floyd are pictured in front of the pickup truck in which they took ristras to market. (Above, courtesy of Jake O. Trujillo family collection; below, courtesy of Horacio and Rosina Martinez.)

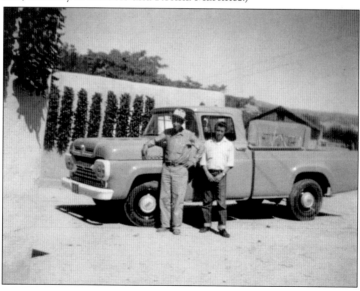

Six

FAMILIES AND ELDERS

Over several generations, Chimayósos spread throughout the region, concentrating in several *placitas* (neighborhoods). Since most Chimayó people did not go outside of the area to marry, a complex tangle of familial relationships resulted, especially within each placita. If neighbors were not related by blood, they were related by marriage.

José Ramón Ortega Vigil was the progenitor of most of the Ortegas currently living in Chimayó. He had 14 children, including five sons and nine daughters; thirteen married into other families, making the extended family very large. One daughter never married.

People who settled in Chimayó were hardworking, self-sufficient pioneers. Longevity was remarkable, considering they could easily be exposed to sickness. Living to be 100 years old was not uncommon. Youngsters were often acquainted with three or four generations of family; and, as a result, they grew up learning to have respect for their elders.

Chimayó, which could be described as rural, open, and neighborly, always had a strong sense of community and was bound closely together by family ties, a strong common religion, economic independence, and a long-treasured heritage of Spanish colonial traditions.

Youngsters were encouraged at an early age to interact with members of the extended family and learn respect for their elders. In this 1950 photograph, young Elizabeth Carmen Trujillo (left) and her sister Shirley Louise pose with their grandmother Francisquita Ortega Trujillo (left) and great-aunt Bonifacia Ortega. (Courtesy of Jake O. Trujillo family collection.)

In this 1962 photograph, Epimenia Ortega Jaramillo (seated at center) celebrates her 95th birthday with her family. Epimenia was married to Pedro Jaramillo, who died several years before she did; she was blind for 10 years before her death in 1962. Standing behind Epimenia are, from left to right, her son Severo Jaramillo holding her great-grandson Tom Cordova, great-grandson Louie Cordova, granddaughter Helen Cordova, great-grandson Tim Cordova, and daughter-in-law Teresita with great-granddaughter Joyce Cordova standing in front. (Courtesy of Tim Cordova.)

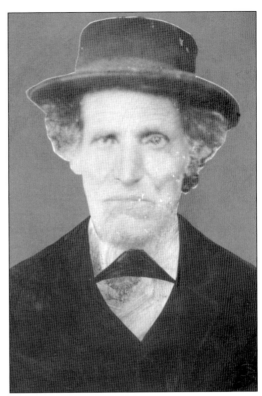

Francisco "Güero" Mestas, pictured at right around 1890, is the legendary Irish great-grandfather to the Ortegas of the Plaza del Cerro. Legend has it that men from Chimayó who headed north to trade and kill buffalo for meat found him with some Indians who had taken him away from his Irish parents as a baby. They stole Mestas away from the Indians and brought him to Santa Cruz, where he was raised by the people who rescued him and given their surname, Mestas. Francisco married Petra Bustos. One of their daughters, Petra Mestas (below), married José Ramón Ortega Vigil, from La Plaza del Cerro, and had 14 children with him. (Right, courtesy of Robert and Andrew Ortega; below, courtesy of Mercedes Trujillo collection.)

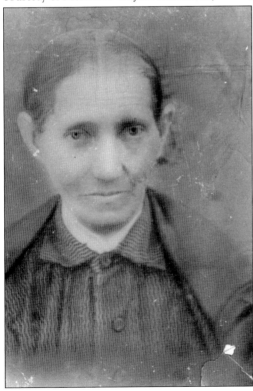

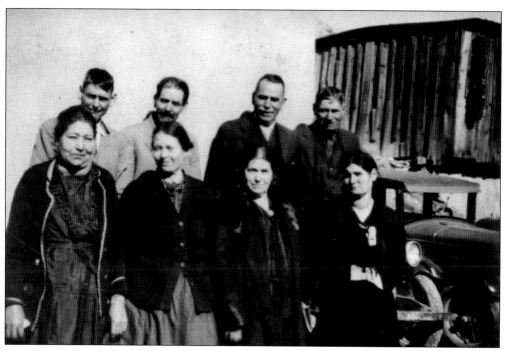

José Ramón Ortega Vigil and Petra Mestas Ortega, from the Plaza del Cerro, were parents to 14 children. In this c. 1935 photograph, eight of the 14 are pictured. They are, from left to right, (first row) Sendaida Ortega Martinez, Francisquita Ortega Trujillo, Escolástica Ortega Martinez, and Bonifacia Ortega; (second row) Nicasio Ortega, Reyes Ortega, Victor Ortega and Rumaldo Ortega. (Courtesy of Mercedes Trujillo collection.)

Bonifacia Ortega, pictured around 1895, was a daughter of José Ramon Ortega and Petra Mestas. She organized the local order of Las Carmelitas and often led the community in prayers and processions. She was known for being very hardworking and skilled at many tasks, like mud plastering, delivering babies, and storytelling. She took care of her parents in their old age. (Courtesy of Mercedes Trujillo collection.)

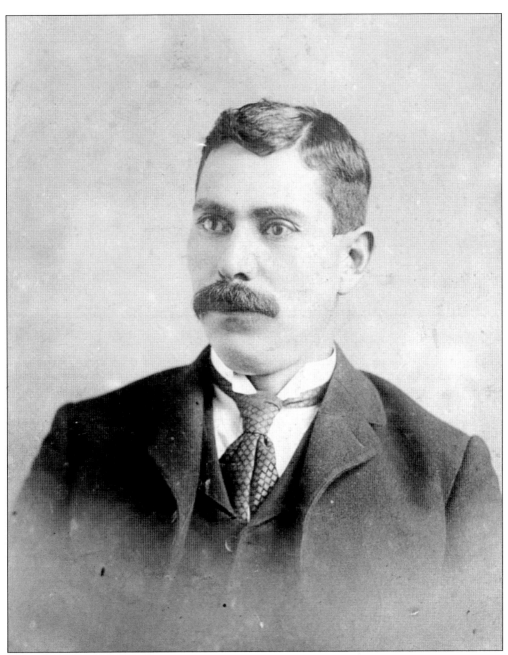

Victor Ortega became the plaza *patrón* (boss) when the torch was passed to him by his father, Jose Ramón, and became one of the most influential figures in the plaza in the early 20th century. He was postmaster from 1904 to 1934 and opened a general store on the plaza in 1907. He was self-taught and became an influential politician in New Mexico's transition from a US territory to a state. He was a representative to the constitutional convention for New Mexico statehood in 1912. He was regarded as a forceful man with a knack for business and hard work. Ortega was known for having good wagon horses, which he and Epimenio Atencio, from Española, would acquire in Colorado and then sell to the people in Chimayó. During the Depression, Ortega served as a schoolteacher and firewood supplier for the school. (Courtesy of Raymond Bal.)

In 1904, Nicasio Ortega, from Plaza del Cerro and the son of José Ramón Ortega and Petra Mestas, married Virginia Trujillo, from Rio Chiquito, daughter of Manuel Trujillo and Antonia Chavez. In 1964, they celebrated their 60th wedding anniversary. Nicasio died later that year, but Virginia lived to be 104 years old. (Courtesy of Robert and Andrew Ortega.)

Concepción Trujillo married Juana Antonia Ortega, and they lived in Rio Chiquito and had nine children. Concepción was one of four sons of José Rafael Trujillo and one of four men from Chimayó who served in the Civil War. Most of Concepción and Juana Antonia's children were weavers and passed on the tradition of weaving to younger generations. (Courtesy of Mercedes Trujillo collection.)

Isidoro Ortega Trujillo (pictured at left around 1895) was one of eight children (six boys and two girls) born to Concepción Trujillo and Juana Antonia Ortega in Rio Chiquito. The 1940 photograph below shows Isidoro (left) standing with two of his brothers, Cicilio (center) and Manuel. Isidoro was born in 1867. He married Francisca "Francisquita" Ortega, from the Plaza del Cerro, in 1892. The couple then went to Durango, Colorado, where he worked in a smelter until 1902. When they returned, they lived in Rio Chiquito for a few years before moving to La Centinela, where he had inherited land from his father and purchased some additional property. He established his ranch, where he cultivated wheat, corn, alfalfa, chiles, melons, and onions and raised horses, cattle, and sheep. (Both, courtesy of Mercedes Trujillo collection.)

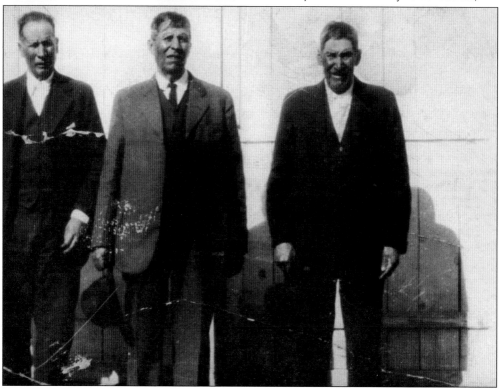

Women were taught to do both inside and outside work. Mercedes Trujillo, daughter of Isidoro Trujillo and Francisquita Ortega, helped her father gather cattle, put up alfalfa, and plant and harvest chiles; cooked; and took care of young nieces and nephews and her elderly grandparents. The photograph at right depicts a pastel painting by Michael Allstead from a 1925 photograph of Mercedes riding one of her father's horses. She was one of the first women in Chimayó to wear pants. Mercedes lived through the 20th century and experienced many dynamic changes. Born in 1904, she not only rode in wagons, but also in cars, trains, and planes. She experienced both having to bring water from the ditch and having running water in her kitchen as well as television and telephones. She spoke both Spanish and English, and taught school, bound dead people, and delivered babies. The image below shows Mercedes at Centinela Fruit Stand when she was 83. (Both, courtesy of Jake O. Trujillo family collection.)

Many people worked hard all their lives and lived to be 100 years old. In this 1993 photograph, Teresita Trujillo Jaramillo is making *pastelitos* (little pies) at age 93. She was the wife of Severo Jaramillo, but learned to weave from her father and mother, Isidoro and Francisquita Trujillo. She and Severo had one daughter, Elena Jaramillo Cordova Teresita lived to be 99 years old. (Courtesy of Tim Cordova.)

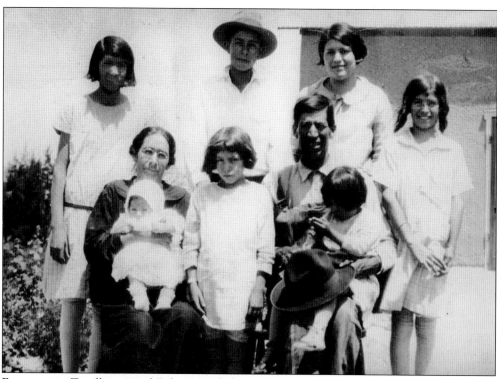

Encarnación Trujillo married Eulogia Roybal in 1904. Encarnación learned how to weave from his father, Concepción Trujillo, and mother, Juana Antonia Ortega, and taught his son John to weave as well. Taken around 1935, this picture shows their family and includes, from left to right, (first row) Eulogia holding Rafael, Rachel, and Encarnación holding Isaida; (second row) Benina, John, Susana, and Clemens. (Courtesy of Carlos Trujillo and Carol Alarid.)

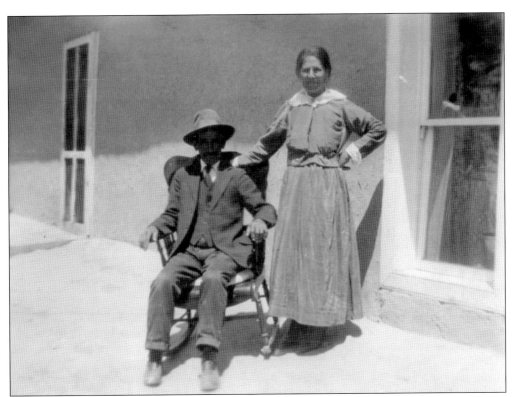

Jacinto and Benita Ortiz are pictured in this c. 1935 image. Jacinto was the first postmaster of Chimayó and served until 1894. Before a priest was assigned to Chimayó, he and Benita provided room and board for the priests from Santa Cruz who came to Chimayó occasionally to administer the sacraments of baptism and First Communion. (Courtesy of Marcela Martinez Garduño.)

Victoria Ortiz Martinez, a sister of Jacinto Ortiz, married Asención Martinez. She and Asención had three children—Enemecio, Apolonio, and Lucia. The Ortiz family originally came from Santa Fe, but many settled in nearby villages like Truchas and Cordova. They raised sheep and provided wool to the weavers of Chimayó. (Courtesy of Mickie Medina.)

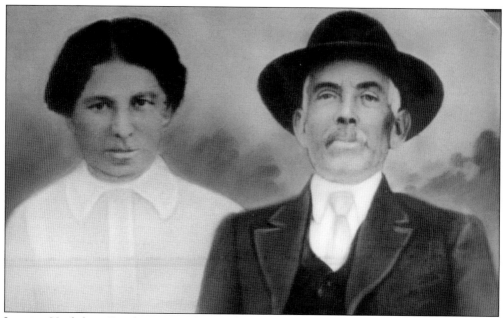

Longino Vigil, from Cundiyo, married Gelacia Chavez, from El Potrero. Gelacia was the daughter of Rafael Chavez, one of Bernardo Abeyta's grandsons, and Libradita Ortega, José Ramón and Petra Ortega's daughter. Longino and Gelacia had nine children—Manuel, Esquipula, Rosarita, Lorenzo, Luicita, Trinidad, Demecia, Noberto, and Prudencio. The daughters were weavers, and the sons were stockmen. (Courtesy of Raymond Bal.)

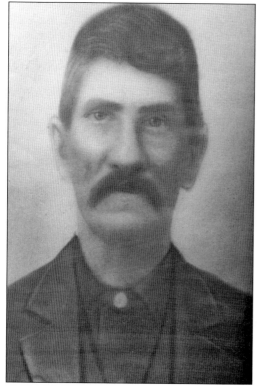

Pictured here around 1900, Pedro Jaramillo was the father of Trinidad Ortega Jaramillo. Trinidad married Hermenejildo Jaramillo, a distant cousin, and they had six children—Roman, Levi, Ruben, Emma, Leonardita, and Guillermo. They also raised their grandson Arturo Jaramillo who, with Florence Jaramillo, established the Rancho de Chimayó restaurant. (Courtesy of Florence Jaramillo.)

Hermerejildo Jaramillo was a skilled builder and was hired to construct several houses in Chimayó in the early part of the 1900s. His specialty was constructing pitched roofs with corrugated metal. He was responsible for building the pitched roof over the Santuario chapel and its two bell towers in 1930. He also oversaw the restoration of the Oratorio de San Buenaventura in the Plaza del Cerro in 1954. He and his wife, Trinidad, are pictured here in stills from the documentary film *Sons of the Conquistadores*, about the people of northern New Mexico, produced and directed by Gordon Knox in 1945. The film is archived at the library of the University of North Texas. (Both, courtesy of Florence Jaramillo.)

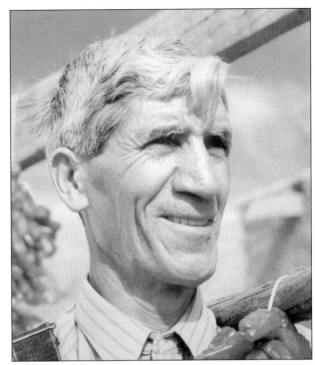

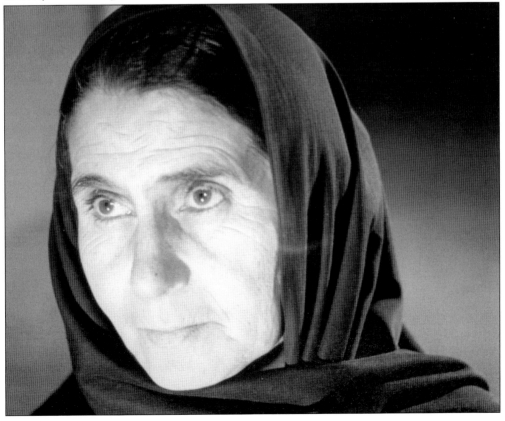

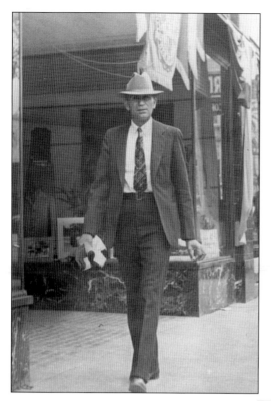

Severo Jaramillo was one of the first people to market Chimayó blankets outside of Chimayó. One of the places he sold blankets was Julius Gans's Southwestern Arts and Crafts Shop in Santa Fe. This 1940 photograph shows Jaramillo walking in the plaza in Santa Fe in front of Gans's shop. (Courtesy of Tim Cordova.)

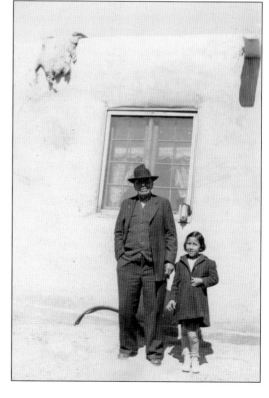

Albino Martinez owned a general store and gas station in the Plaza Abajo. He married Manuelita Martinez and they had four children—Bonifacio, Asención, Ursulo, and Juanita. Albino is pictured standing in front of his store in 1943 with his granddaughter María. Note the sheepskin curing on the roof. (Courtesy of David and Diane Martinez.)

Higinia and Marcos Trujillo lived in Rio Chiquito and had nine children. Higinia, a daughter of Reyes and Genara Trujillo and granddaughter of Concepción and Juana Antonia Trujillo, was a weaver. Marcos was the son of Bonifacio and Felicita Trujillo, of El Potrero, and a great-grandson of Bernardo Abeyta. (Courtesy of Dulcinea Vigil.)

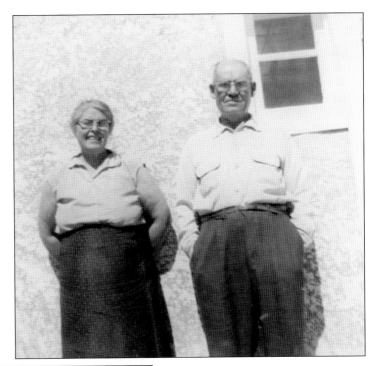

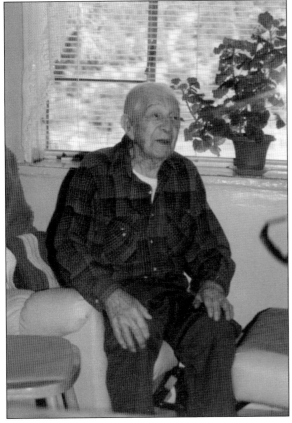

Esquipula Vigil was a son of Longino Vigil and Gelacia Chavez. Esquipula married Francisquita Trujillo, daughter of Manuel Trujillo and Antonita Chavez, of Rio Chiquito. Francisquita was a weaver and taught the skill to her children, many of whom were contract weavers for the Ortegas and Trujillos. Esquipula is pictured in 1995, when he was 105 years old. (Courtesy of Dulcinea Vigil.)

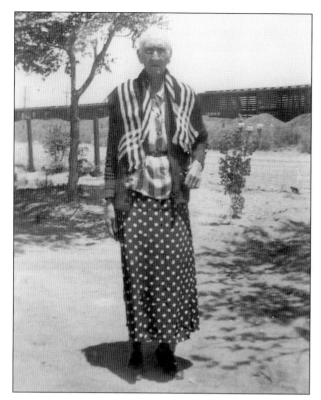

Ruperta Martinez Chavez, pictured around 1940, was married to Juan Ramón Chavez in 1889. Juan Ramón was a son of María Carmen Abeyta (Bernardo Abeyta's daughter) and Manuel Chavez. Juan Ramón inherited his mother's house, where Bernardo Abeyta had lived, and Ruperta was the last to live there before her death in 1951. Remnants of the house remain on the hill south of El Santuario. (Courtesy of Mickie Medina.)

Lucia Martinez Fresquez was the second wife of Pedro Fresquez, and is pictured around 1940 in front of the Santa Rita chapel that her brother, Enemecio Martinez, built in 1929. Lucia helped Enemecio maintain the chapel and often made dresses for the *santos* on the altars of the chapel and of the nearby morada to which her husband, Pedro, and brother Enemecio belonged. (Courtesy of Josie Martinez.)

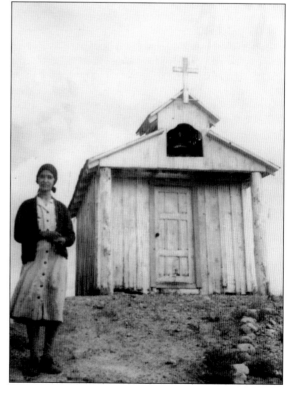

Seven

INTO THE NEXT CENTURY

When Mexico and most of the remaining Spanish colonies obtained independence from Spain in 1821, the Santa Fe Trail was established, encouraging trade between the United States and the newly created area known as New Mexico. People from New Mexico traded what they produced, like foodstuffs, weavings, and livestock (mules and donkeys) that were unknown to those from the East. Goods brought to New Mexico from the East included metal items, dyestuffs, and other types of unfamiliar food.

In 1846, New Mexico became a possession of the United States under the Treaty of Guadalupe Hidalgo. Construction of the railroad and the establishment of a station in Española in 1880 meant that goods could be exchanged at a faster rate and people could be transported to this outlying area faster and more easily. After all, Española was located only 10 miles from Chimayó. For people in Chimayó, economic self-sufficiency gave way to a cash economy, making it necessary for people to find ways to make money. Many men went north to Colorado, Wyoming, or Montana to work for months out of the year in mines or as herders on sheep ranches to provide for their families. Women stayed home to maintain the family and the farm.

In 1912, New Mexico became a state. Given the area's far-flung location, development was slower than in any other state in the union at the time. Before statehood, New Mexico had experienced a history of isolation, but now it was governed by an entity that was culturally different from what the people of the state were used to.

As citizens not only of New Mexico but also of the United States, men were subject to having to serve in the armed forces to defend the country. This brought a new, global perspective to what had been an isolated part of the world.

The dynamics of life in Chimayó were changed forever with the onset of World War II. The atomic age began 35 miles away, in Los Alamos, where the nuclear bomb was developed. People now had sources of employment closer to home—not only in Los Alamos, but also in local businesses that sprang up because of money injected into the local economy.

New Mexico became a US territory in 1850 and a state in 1912. Men from Chimayó used the requirement for military service as an opportunity to enlist in the armed forces in order to collect an allowance or pension that would help the economic conditions of their families. Enemecio Ortiz Martinez enlisted in the US Army in World War I. In this 1917 photograph, he is preparing to leave for the service. (Courtesy of Mickie Medina.)

In World War II, many young men from Chimayó chose to enlist in their preferred service instead of being drafted. In 1941, Jacobo Trujillo (left) and his brother Antonio Máximo (right) pose with their younger brother, Rosinaldo (center) on the front porch of their home at La Centinela before leaving to serve in the US Navy. (Courtesy of Mercedes Trujillo collection.)

David Ortega served in the US Army in World War II and was stationed in Oakland. In this 1943 photograph, Ortega is pictured with his wife-to-be, Jeanine Williamson, as they walk in San Francisco. After the war ended, they came back to live in Chimayó, and David joined his father, Nicasio, and brother José Ramón in their weaving business. (Courtesy of Robert and Andrew Ortega.)

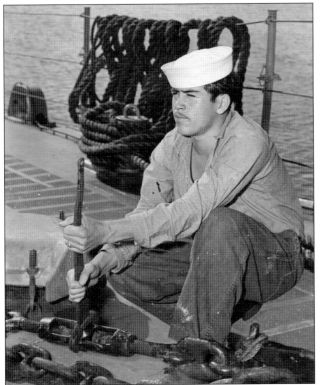

Young men from Chimayó also enlisted in the service during the Korean War—not only to choose the branch of the military to serve, but also to receive an allowance that could be sent back home. Horacio Martinez, son of Esquipula Martinez and Teresita Trujillo, is pictured on the USS *McGinty* in 1953. (Courtesy of Horacio and Rosina Martinez.)

After World War II, Los Alamos Scientific Laboratory provided work opportunities for people from Chimayó and other places in northern New Mexico. For security purposes, only those with badges could enter the area. A bus was provided for people from Chimayó who got a job in Los Alamos. In the 1946 photograph at left, Frank Medina is pictured with his son on the hood of the bus that he drove from Chimayó to Los Alamos. By 1952, more people from the valley worked in Los Alamos, and the number of buses increased. The 1952 image below shows Medina (left) and an unidentified companion standing next to newer buses that they drove for commuters living in Chimayó and Española. (Both, courtesy of Leona Medina Tiede.)

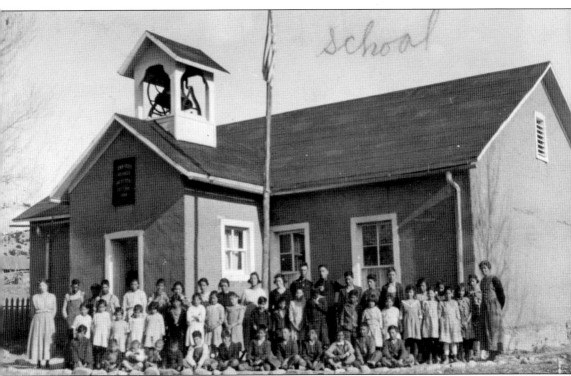

Presbyterian missionaries came to Chimayó in 1898, and a Presbyterian mission school was established in the Plaza del Cerro in 1900. The first mission teacher was Prudence Clark, who came from Eden Prairie, Minnesota. In 1901, the Presbyterians built a new school just outside of the plaza. The schoolhouse was dedicated to John Hyson and featured a bell that was used to call children to their classroom. The bell also rang for momentous occasions, including funerals and weddings. Evangelical services were held in the schoolhouse, and the Presbyterian congregation continued to grow. A Presbyterian church was built in 1933. The mission teachers introduced their culture from outside of Chimayó, like medicines, health care, food-preparation techniques, and better standards of sanitation. This photograph shows John Hyson Schoolhouse in 1920. (Courtesy of the Chimayó Museum.)

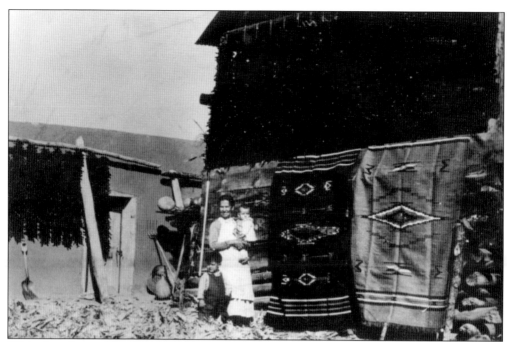

With the advent of the widespread use of automobiles, little stores began to appear along the main road. These stores provided miscellaneous merchandise and sold local weavings to tourists visiting Chimayó. Ursulo Ortiz Sr. sold Chimayó blankets from his home/store that he started in 1922. The c. 1936 photograph above shows Ortiz Sr.'s mother, Benita, with her granddaughter in front of the house where Chimayó blankets are hanging for display. Pictured below is a general mercantile store built in the early 1900s and owned by Demecio Martinez. In 1985, John Abrams purchased the building and designed and restored the structure, turning it into Chimayó Trading & Mercantile, a gallery featuring Native American pottery, jewelry, and rugs. (Above, courtesy of Angélica Martinez Medina; below, courtesy of John Abrams.)

In the 1936 image at right, Lucinda Martinez and her cousins, Angelica and Vicente Martinez Jr., stand in front of a gas pump operated by her parents, Teodoro and Froila Martinez. At the time, few people owned cars, but those who did had to either have gas pumps to fuel the car or buy gasoline from people who owned gasoline pumps. In the 1929 photograph below, Vidal Martinez stands next to a gas pump owned by his father, Albino Martinez, whose pump was associated with a general store. (Right, courtesy of Angelica Martinez Medina; below, courtesy of David and Diane Martinez.)

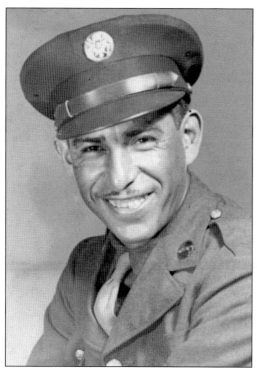

Juan Climaco Medina served in the US Armed Forces in World War II and returned to Chimayó after the war. He served as Santa Fe County commissioner for three terms and was instrumental in improving the access to Chimayó via State Road 503 and County Road 98. Subsequently, County Road 98 was named Juan Medina Road in his memory. (Courtesy of Dennis and Leona Tiede.)

As cars became more common in Chimayó, people could go out of town to shop for clothes. In this c. 1930 picture, Celestina Jaramillo Martinez (left) and Benita Fresquez Martinez are dressed in the latest styles because being married to brothers—Benita to Enemecio, and Celestina to Apolonio—they could go to town in Enemecio's car. (Courtesy of Mickie Medina.)

Pedro Trujillo (at far left behind second row) was the teacher of this 1932 class at the Plaza del Cerro School. Students pictured are in third, fourth, and fifth grades. The school burned down and was replaced with a Santa Fe county school east of the Plaza del Cerro. (Courtesy of Raymond Bal.)

After being in Chimayó for 20 years, Prudence Clark Ortega (far left, against the wall) continued teaching, but not at the Presbyterian-established schools. In this 1920 photograph, she stands with her class at a school at La Cuchilla. Two other schools existed in Chimayó—one at Plaza del Cerro and another in the Plaza de Abajo. (Courtesy of the Chimayó Museum.)

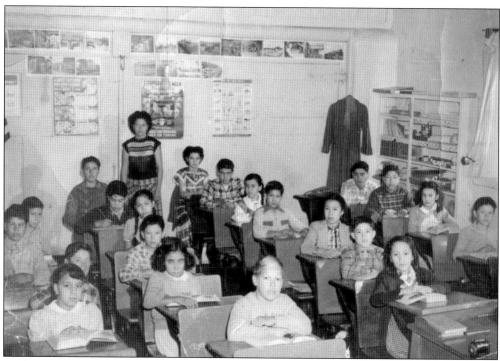

In this 1948 image, Eremita Martinez stands next to 21 students from Chimayó in her fifth grade class in the Santa Fe County School. A larger consolidated public school was built in the 1960s in another, more centralized area of Chimayó, and the old school building was converted to a community center for the Santa Fe County portion of Chimayó. (Courtesy of Elma and Raymond Bal.)

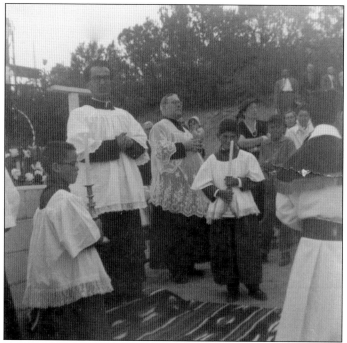

Fr. Casimiro Roca, S.F., in the foreground of this 1956 photograph, was instrumental in organizing the community and building or restoring chapels and cemeteries in each of the family neighborhoods in Chimayó. Descendants of Concepción Trujillo made up the residents of the community of Rio Chiquito neighborhood. (Courtesy of Holy Family Parish Archives.)

Tourism became important to businesses in Chimayó, especially those that preserved or maintained a tradition like weaving or those catering to visitors. Jake Ortega Trujillo welcomes guests to the weaving shop that he established after retiring from working in Los Alamos in 1975. In 1983, he opened Centinela Traditional Arts and sold his weavings and those of his son Irvin and daughter-in-law, Lisa. In the 1942 photograph below, Alfonsa Ortega Vigil (second from right) stands with visitors at her home next to the Santuario. (Right, courtesy of Irvin Trujillo; below, courtesy of Raymond Bal.)

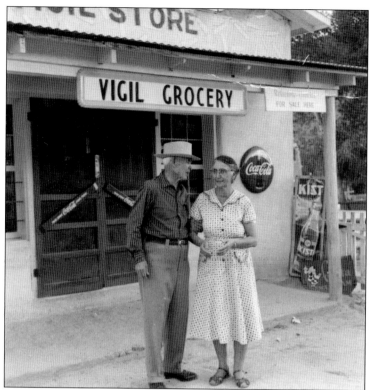

Jose Manuel Chavez Vigil and his wife, Alfonsa Ortega Vigil, stand in front of their El Potrero store, located next to the Santuario, in this 1959 picture. The store has served visitors to El Potrero since it was built in 1949. Although both Jose Manuel and Alfonsa have died, their daughter Elma and grandchildren Raymond Bal and Vicki Bal-Tejada continue operating the store. (Courtesy of Raymond Bal.)

Most people in Chimayó did not have running water until after 1950. The Presbyterian missionaries who arrived in the 1900s introduced outhouses to Chimayó. Outhouses were constructed simply, with rough lumber. Remnants of outhouses—like this one near La Cuchilla—can still be found. (Courtesy of Rosina and Horacio Martinez.)

Chimayó chile has become an attraction to outsiders because of its decorative characteristics. It was common to hang the strings under the eaves of the house, which was not only practical, but also ornamental. In this 1987 photograph, Dimas and Dulcinea Vigil, of Rio Chiquito, stand in front of their house, which is adorned with strings of chile hung out to dry for winter storage. (Courtesy of Holy Family Parish Archives.)

In 1965, the Chimayó volunteer fire department began raising funds to purchase a fire truck and firefighting equipment. Completion of the Chimayó unit reduced fire insurance rates in the coverage area. Standing next to the new fire truck at the grand opening of the fire station are, from left to right, Mercedes Trujillo, Joe Trujillo, Porfirio Archuleta, and Jake O. Trujillo. H.M. Victor Archuleta is the child in front. (Courtesy of Jake O. Trujillo family collection.)

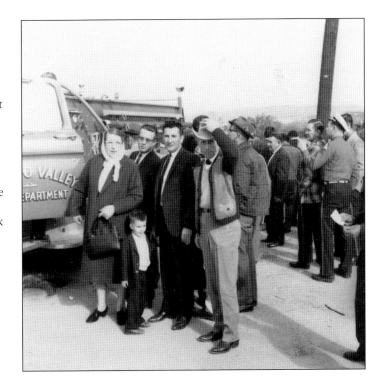

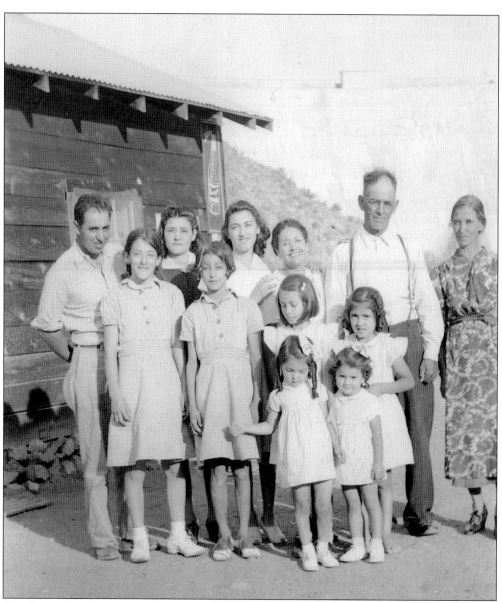

The Santa Cruz Dam created a reservoir that turned into a recreation area for boating, fishing, and picnicking. People from Chimayó could visit the lake for outings with their families. In this c. 1940 photograph, Pedro Fresquez and his wife, Lucia, are enjoying a day at the lake with their granddaughters. They stopped to pose with his daughter Bernarda and her husband, José Ramón Ortega, who was working as a caretaker at the lake. Pictured, from left to right, are (first row) Evangeline Ortega and Lydia Martinez; (second row) Josie, Rita, Zoraida, and Mickie Martinez; (third row) José Ramón Ortega, Tillie Martinez, Elena Martinez, Bernarda Ortega, Pedro Fresquez, and Lucia Fresquez. (Courtesy of Mickie Medina.)

Thousands walked to Chimayo before dawn on Good Friday.

Mary and Frank Martinez walk up U.S. 258 from Santa Fe.

In 1946, a group of veterans who survived the Bataan Death March in World War II made a pilgrimage on Good Friday to give thanks for surviving and to honor those who lost their lives. Since the first event, thousands of pilgrims have made a yearly trek to the Santuario de Chimayó on Good Friday. Many have special intentions or petitions for health or walk in memory of a loved one or in thanksgiving for spiritual and temporal healing. People from miles away will walk for several days to arrive at the Santuario on Good Friday. These images are from the April 19, 1981, edition of the *Santa Fe New Mexican*. (Courtesy of Holy Faith Parish Photo Archives.)

This 1981 photograph, taken by Kevin Bubriski, shows Leroy Perea making a 32-mile pilgrimage from Santa Fe to the Santuario de Chimayó before Good Friday. He carries a cross carved by his father and grandfather. Thousands of pilgrims make private journeys during Holy Week, before Good Friday, to avoid the crowds. (Courtesy of Holy Family Parish Archives.)

A revival of Spanish Colonial folk art encouraged people from Chimayó to continue making traditional art, including woodcarving of religious images, weaving, and tinwork. This 1986 photograph shows Apolonio Martinez holding a woodcarving that he made of San Isidro, and his wife, Celestina, holding a rug that she wove. (Courtesy of Carlos Trujillo and Carol Alarid.)

In addition to weaving shops, other types of galleries were opened after 1960 to cater to tourists visiting Chimayó. In this 1986 image, Paul Ortega stands next to the entrance of the newly opened gallery belonging to his parents, Andrew and Evita Ortega, and located in the home of José Ramón Ortega Vigil and Petra Mestas Ortega in the Plaza del Cerro. José Ramón and Petra were Paul's great-great-grandparents. (Courtesy of Andrew Ortega.)

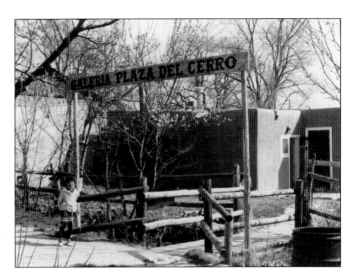

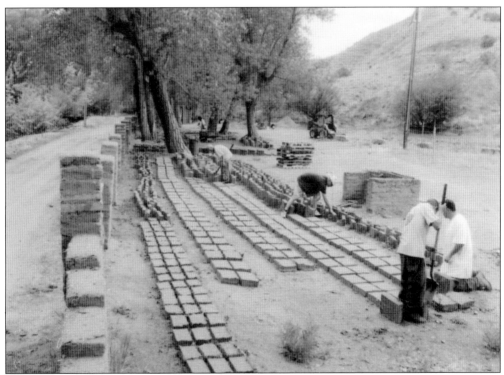

The Chimayó Youth Conservation Corps is a nonprofit organization that was formed in 2006 to provide the youth of Chimayó and other parts of northern New Mexico with alternatives to drugs, gangs, crime, and possible incarceration by offering opportunities to learn skills such as how to work in land conservation and preservation of cultural traditions. This 2007 photograph shows youths making adobe bricks for use in construction. (Courtesy of Suellen Strale.)

The Spanish brought donkeys to the Southwest when they arrived in 1598, and the animals became the area's principal beasts of burden. In Chimayó, donkeys were more common than horses in the early days of settlement, but were replaced by horses over time. In 1983, Marco Oviedo, together with his wife, Patricia, reintroduced donkeys to Chimayó by establishing a herd of a heritage breed—known as Mammoth donkeys—at Centinela Ranch. Marco also established a state-of-the-art reproduction laboratory to freeze semen from jacks (male donkeys) or stallions, to perform embryo transfers on mares, to perform artificial insemination, and to ship fresh, cooled equine semen to other farms around the country. Marco is pictured in this 1987 image with a Mammoth jack that stands over 17 hands (68 inches at the base of the neck). (Courtesy of Marco A. Oviedo.)

Besides being used for packing or plowing, these large donkeys could be saddled. Above is a Mammoth saddle donkey that was used to give trail rides. Below is a 1987 picture of a donkey trail ride known as Paseo de La Tierra Vieja (ride of the old land), a business established by Marco and Patricia Oviedo at La Centinela. Tourists could take a short, one-hour ride and see a majestic view of the Chimayó valley while hearing about its history. The Oviedos no longer give trail rides, but still maintain a breeding farm of the rare equines. (Both, courtesy of Marco A. Oviedo.)

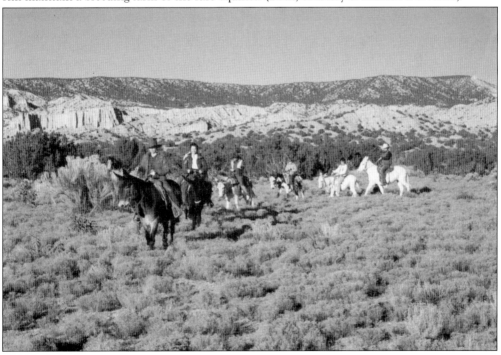

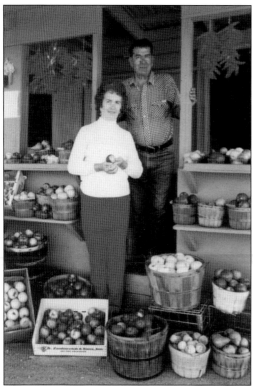

Ralph and Rosalie Trujillo sustained themselves through operating a fruit stand to sell produce they harvested from the farm. While serving in Guam during the Korean War, Ralph met Rosalie and married her. After the war, they returned to Chimayó to help Ralph's father, Encarnación, with the farm, raising various kinds of apples, peaches, pears, chiles, and corn. This photograph was taken around 1988. (Courtesy of Lindsey Trujillo.)

Isabelle (left), Jake, and Mercedes Trujillo, of La Centinela, are pictured in 1980 at the roadside stand in front of their home along the highway. Chimayó chile and apples, with their distinctive flavor, were most popular with visitors. Selling produce at the stand allowed the Trujillos to make money while meeting visitors to Chimayó. (Courtesy of the Jake O. Trujillo family collection.)

Arturo and Florence Jaramillo opened the Restaurante Rancho de Chimayó in 1965 in the ancestral home of the Jaramillo family. The 1940 photograph above shows Hermenejildo and Trinidad Jaramillo standing in front of their home (built in 1890) that would later become the restaurant. The historical integrity of early architecture of the Spanish American frontier was maintained when the structure was converted to a restaurant. The restaurant features authentic homemade northern New Mexico cuisine and is staffed by employees from Chimayó. The Rancho de Chimayó is a popular destination for visitors from all over the world as well as local patrons. (Above, courtesy of the Emma Jaramillo Montes Collection; below, courtesy of Florence Jaramillo.)

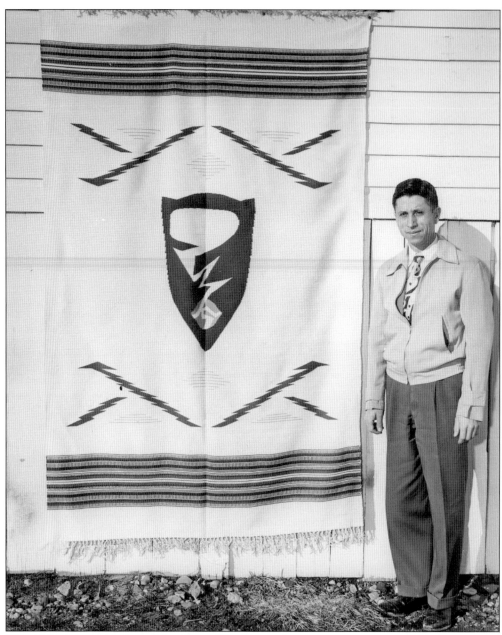

This 1948 photograph shows Jake Ortega Trujillo standing next to a weaving depicting an image of the first atomic bomb, which he wove as a special commission. The weaving is an example of taking a typical Chimayó tradition to the next level by incorporating custom, artistic designs into a Chimayó-style textile. After World War II, Los Alamos Scientific Laboratory provided a source of employment for many in Chimayó. Working nearby allowed Chimayósos to continue following traditions like weaving while adapting to modern American society. Before, designs in Chimayó blankets were mostly directed to the curio trade. In this weaving, Trujillo went beyond tradition to weave an art form that expressed an idea and made a statement about a timely and controversial issue. (Courtesy of the Jake O. Trujillo family collection.)

BIBLIOGRAPHY

Chavez, Fray Angelico. *Origins of New Mexico Families in the Spanish Colonial Period—In Two Parts: The Seventeenth (1598–1693) and Eighteenth (1693–1821) Centuries.* Santa Fe: Historical Society of New Mexico, 1954.

Frank, Larry, and Skip Miller. *A Land So Remote: Religious Art of New Mexico 1780–1907.* Vol. 1. Santa Fe: Red Crane Books, 2001.

Friese, Kurt Michael, Kraig Kraft, and Gary Paul Nabhan. *Chasing Chiles: Hot Spots Along the Pepper Trail.* White River Junction, VT: Chelsea Green Publishing, 2011.

Jamison, Cheryl Alters and Bill Jamison. *The Rancho de Chimayó Cookbook: The Traditional Cooking of New Mexico.* Boston: Harvard Common Press, 1991.

Jaramillo, Cleofas M. *Shadows of the Past (Sombras del Pasado).* Santa Fe: Ancient City Press, 1972.

Kay, Elizabeth. *Chimayó Valley Traditions.* Santa Fe: Ancient City Press, 1987.

Lovato, Phil. *Las Acequias del Norte.* Taos: Community Ditch Systems of Northern New Mexico, 1974.

Lucero, Helen R. and Suzanne Baizerman. *Chimayó Weaving: The Transformation of a Tradition.* Albuquerque: University of New Mexico Press, 1999.

McKay, Mary Terence, and Lisa Trujillo. *The Centinela Weavers of Chimayó: Unfolding Tradition.* Chimayó: Centinela Traditional Arts, 1999.

Pierce, Donna and Marta Weigle, ed. *Spanish New Mexico: The Spanish Colonial Arts Society Collection.* Vol. 2. Santa Fe: Museum of New Mexico Press, 1996.

Roca, S. F., Casimiro. *A Little Priest for a Little Church: The Story of the First Pastor of El Santuario de Chimayó.* Chimayó: Hijos de La Sagrada Familia, 1996.

Santa Cruz Parish. *La Iglesia de Santa Cruz de La Cañada.* Santa Cruz, NM: Santa Cruz Parish, 1983.

Sons of the Holy Family. *El Santuario . . . A Stop on the "High Road to Taos."* Silver Spring, MD: Sons of the Holy Family, 1994.

Stephenson, Claude, ed. *Matachines! Essays for the 2008 Gathering.* Santa Fe: New Mexico Arts, a Division of the Cultural Affairs Department, 2008.

Thomas, D.B. *From Fort Massachusetts to the Rio Grande: A History of Southern Colorado and Northern New Mexico from 1850–1900.* Washington, DC: Thomas International, 2002.

Usner, Don J. *Sabino's Map: Life in Chimayó's Old Plaza.* Santa Fe: Museum of New Mexico Press, 1995.

DISCOVER THOUSANDS OF LOCAL HISTORY BOOKS FEATURING MILLIONS OF VINTAGE IMAGES

Arcadia Publishing, the leading local history publisher in the United States, is committed to making history accessible and meaningful through publishing books that celebrate and preserve the heritage of America's people and places.

Find more books like this at
www.arcadiapublishing.com

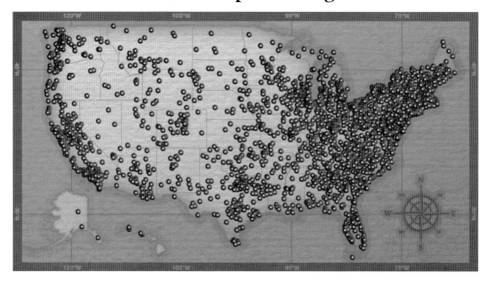

Search for your hometown history, your old stomping grounds, and even your favorite sports team.